An Introduction to
Digital Photomicrography

Brian Matsumoto and Carol Roullard

THE CROWOOD PRESS

First published in 2017 by
The Crowood Press Ltd
Ramsbury, Marlborough
Wiltshire SN8 2HR

www.crowood.com

© Brian Matsumoto and Carol Roullard 2017

All rights reserved. No part of this publication may be reproduced or transmitted in any form or by any means, electronic or mechanical, including photocopy, recording, or any information storage and retrieval system, without permission in writing from the publishers.

British Library Cataloguing-in-Publication Data
A catalogue record for this book is available from the British Library.

ISBN 978 1 78500 304 2

Frontispiece: Cholesteryl hexanoate crystals recorded using polarized light, Sony a7R II, Olympus BX51 microscope, 10x objective, 2.5x eyepiece. (*Slide and image: Carol Roullard*)

Typeset by Sharon Dainton
Printed and bound in India by Replika Press Pvt Ltd

An Introduction to
Digital Photomicrography

CONTENTS

1	INTRODUCTION TO THE MICROSCOPE	7
2	MICROSCOPE PARTS IN GREATER DETAIL	17
3	EXPANDING THE SYSTEM	32
4	INTRODUCTION TO CAMERAS	45
5	DIGITAL CONCEPTS	62
6	IMPROVING IMAGES	78
7	MOVIES	95
	FURTHER INFORMATION	105
	INDEX	107

A slide of diatoms arranged by Klaus Kemp. Photographed with a Leitz Orthoplan microscope with a colour Heine condenser, 10x objective, 2.5x eyepiece. *(Image: Brian Matsumoto)*

INTRODUCTION TO THE MICROSCOPE

To the neophyte, using a microscope might seem intuitive. All one has to do is turn on the illuminator, place a specimen on the stage, centre it, focus, and view. Unfortunately it's not that simple. In order to get the best results, the microscopist must know how to control his illuminator, and what type of adjustments must be made with different types of specimen. The lighting used for recording the activity of pond animals will be different from that used for viewing stained slides, and a failure to adjust the microscope to the specimen being observed would lead to less than optimum viewing.

If one wishes to take good photographs, using the microscope requires a rigorous attention to details. A camera records accurately while the human eye tends to view subjectively. If the photographer does not use the right illuminator, the right filter or the right software setting on his camera, the photograph will show a colour cast.

It is essential to learn how to use the correct visual and photographic techniques. This is accomplished by making a routine for setting up the microscope. The first step is to adjust the illumination; the second step is to use the microscope controls for focusing and moving the slide about. The third and final step is to adjust the camera to take photographs. One will have to match the camera's sensor output to the light source and adjust its exposure.

We encourage the new microscope user not to be intimidated by the expensive microscopes used by the knowledgeable hobbyist or the research scientist. With a relatively modest outlay, one can start taking quality pictures. If this is your first time trying photography through the microscope, we recommend starting with the simpler microscope stands. The so-called student stands used in colleges or grade schools can be effective for taking pictures of fascinating pond creatures. If you find this hobby absorbing, you will purchase a more advanced microscope and camera. In fact, you will find that one microscope is not enough.

This chapter introduces the microscope by describing its controls used most frequently. Chapter Two covers the parts of the microscope in greater practical and theoretical detail. Taken together, these chapters provide the basics to get immediate results. Later chapters cover more sophisticated steps and techniques to enable you to build on the basic knowledge, and to understand how to perform the new techniques successfully.

Simple Versus Compound Microscope

An understanding of light's interaction with the specimen and the microscope will help you decide which lens to use and how much magnification is needed to discern fine structures. This chapter provides a simplified explanation of optics to help you become familiar with additional terms and principles. There will be a minimum number of equations with the emphasis on providing you with an intuitive and pragmatic approach to the workings of the microscope. This discussion is helpful in understanding objective lens and eyepiece nomenclature.

From time to time we will include titled boxes with content, called 'sidebars'. These sidebars contain standalone discussions on subjects that are outside the regular flow within the chapter. They can be read

when referred to within the chapters or at your leisure.

The simplest microscopes are magnifiers or loupes. These hand-held lenses are easily used at 10x and require to be held close to the eye. Focusing is accomplished by varying the distance between the object and the lens. The loupes are a biconvex lens.

A biconvex lens is an example of a simple microscope (Fig. 1). It has convex surfaces on each side and an optical axis, a line that passes through the centre of curvature of the lens. Light rays travelling parallel to this optical axis pass through the lens and converge to a point on its opposite side. This is defined as the focal point, and its distance from the lens defines its focal length.

Fig.1 Parallel light rays passing through a simple lens converge to a focal point.

If you take a simple biconvex lens and place it close to an object, within its focal point, you will generate an image that can be seen from the opposite side of the lens. The image is observable when the lens is placed close to the eye and the subject appears enlarged and upright. This is a virtual image because it cannot be projected on to a screen.

A lens can also form a real image, one that can be projected on to a screen or captured by a camera. This is accomplished by placing a subject on one side of the lens so that it lies outside the front focal point. A real inverted image will be projected on the opposite side of the lens and can be projected on a screen. This is how an objective lens works. By using a second lens, the real image can be viewed at higher magnification. In essence, the second lens (eyepiece) acts as a magnifier amplifying the real image. Since the real image is inverted, it retains this feature when viewed through the eyepiece. Each lens provides magnification, and the effect is multiplicative so that a 10x objective and a 10x eyepiece create an image at 100x. A compound microscope is one with an objective lens and an eyepiece. This is the instrument that most people envisage when they talk about a microscope.

Basic Microscope Parts

First, when using the microscope the typical specimen is mounted on a 25 x 75mm glass slide that is approximately 1mm thick. One might be surprised by its cost, but it should be remembered that slides are precisely ground as optical defined surfaces with their upper and lower surfaces parallel to each other. Overlying the specimen is a thin glass coverglass. For the professional, these two items are typically purchased in large volumes from a scientific supply house. However, the hobbyist can find smaller quantities of these items on eBay where the price is generally much lower. Frequently, a laboratory liquidates its unused supplies and purchasing slides, and coverglasses from such a source can be a bargain. See the 'Microscope Slides and Coverglasses' sidebar to learn more about

INTRODUCTION TO THE MICROSCOPE 9

> **MICROSCOPE SLIDES AND COVERGLASSES**
>
> Microscope slides should be 25 x 75mm and 1mm to 1.03mm thick. The defined thickness is needed so that the condenser from the microscope's illumination system can focus light on the specimen.
>
> Coverglasses can be obtained in a variety of sizes, but square coverglasses, 22mm to 14mm per side, are popular. Coverglass thickness should be #1.5 (an arbitrary nomenclature provided by the manufacturers), but if these are unavailable you should select a slightly thinner coverglass (#1 thickness) over a slightly thicker one (#2 thickness). The importance of coverglass thickness will be discussed in Chapter 2. Coverglasses with thicknesses of #2 or #3 are more robust; however, they will degrade the image when working with powers greater than 200.

the slide and coverglass specifications you should look out for.

A compound microscope has three groupings of microscope controls: the first is the stage for holding the slide with the specimen, the second comprises the focusing knobs to obtain a sharp image, and the third comprises the condenser and mirror for optimizing illumination (see Fig. 2). The complexity of these controls varies with different microscope models. For a student microscope the stage is a simple flat plate with two spring clips to hold down the microscope slide. Finger pressure is used to move the slide across the stage and to centre the subject within the field of view. For low magnification work from 40x to 200x this is adequate, and a skilled worker can manually manipulate slides at magnification as high as 400x.

While appearing simple, the stage is a precisely engineered flat plate located in the mid-region of the microscope. Its smooth surface is perpendicular to the viewing optics, and permits minute movements of the slide without any friction or sticking. The slide is laid flat on the stage with the specimen and coverglass facing the objective. An upright microscope is configured so that the objective is over the specimen, while an inverted microscope is one where the objective is beneath the specimen.

As one uses higher magnification, greater precision is needed to move the slide. Research microscopes are equipped with a mechanical stage to hold the slide. This device has two knobs for orthogonally moving the slide. The slide is placed on the stage, and two clips, one spring-loaded, grip the slide securely. Turning the knobs moves the slide along the stage's surface. Index marks and a millimeter scale are inscribed on the mechanical stage for recording the position of the slide. A vernier allows its position to be recorded with an accuracy of 0.1mm.

The microscopist focuses the specimen by varying the distance between it and the microscope optics. In older microscopes, the objective lens and eyepiece were mounted on a single tube whose height could be varied over the stage. In this design, the slide is fixed and the viewing optics are raised or lowered. Many of these microscopes were equipped with an inclination joint for tilting the tube to position the eyepiece at a comfortable angle for viewing. For photography, the tube was set vertically so the camera could

Fig.2 Research microscope with a trinocular head designed for photomicrography.

then be mounted over the eyepiece. If a camera is mounted on the microscope's tube, it should be as light as possible because the focusing controls must lift and lower its weight while focusing. We found cameras weighing 1lb (0.45kg) or less are easily accommodated by older microscopes, and the effort to turn the coarse focusing knob was acceptable.

On modern research microscopes, the entire stage assembly is moved while the optical train is fixed. This has the advantage that the focusing gears have to drive only the weight of the stage assembly. This is desirable if one wishes to mount a heavy digital camera on to the microscope. It should be noted that the coarse focus of some microscopes, such as the Zeiss GFL or the Wild M20, lift and lower the body tube while the fine focus moves only the stage. For such microscopes, one should select lighter cameras as coarse focusing gears must lift and lower the weight of the camera as well as the microscope body.

Many readers may already own a microscope designed for photomicrography. Such stands have a trinocular head: two eyepiece tubes dedicated for visual use and the third dedicated for photography. Such stands allow the user to switch quickly and conveniently from visual observation to recording the image with a camera.

The paired visual eyepieces have adjustments for obtaining binocular vision. The two eyepieces can be moved closer together or further apart to accommodate the variations in interpupillary distance. To compensate for differences in the strength of the eyes, one of the eyepieces has a knurled control that can slightly adjust its focus. This ensures that both the left and right eyes will see a sharply focused image. The photographic tube is orientated vertically and serves to hold the digital camera. A slider on the side of the body directs the light to either of the two eyepieces or the camera.

The eyepieces, also called oculars, have an engraved magnification number followed by an x representing the power of the eyepiece. Together with the objective's power, the user can determine the visual magnification of the microscope. The magnification equals the multiplied value of the eyepiece and the objective. For example, if the objective is 100x and the eyepiece is 10x, the total magnification power is 1000x. In some cases the eyepieces are inscribed with a field number which specifies the extent of the field of view. This number when divided by the magnification of the microscope objective provides the diameter in mm that is being viewed.

The controls and optics for illuminating the specimen are found beneath the stage. Almost all modern research microscopes have a built-in illuminator that lights the specimen according to procedures described by August Köhler (see the section at the end of this chapter, 'Instructions for Obtaining Köhler Illumination'). Understanding this procedure is necessary for high-resolution imaging. Considering that the illuminator is built in, it is easy to set up Köhler illumination. In the base of the microscope is the field diaphragm that can be opened or closed with a large, knurled ring (Fig. 3). This controls the expanse of light illuminating the specimen; a larger opening lights a larger area of the viewing field, while a smaller opening lights a smaller portion. Higher contrast images are obtained by restricting the light to just the area that is being viewed.

Microscopes have two focusing control knobs: coarse and fine. Typically, the coarse focus knob is larger in diameter and is found underneath the stage to the rear of the microscope. It is used to move the

Fig. 3 The base of a Zeiss microscope with a partially closed field diaphragm.

Fig. 4 Close-up of the fine focus knob of an Olympus microscope showing the tick marks.

stage rapidly up and down, and serves to obtain rough focus. This focus knob allows the user to focus the lower powers, as well as increase the clearance of the lens when large objects are added or removed from the stage. Higher magnification work requires using the fine focus knob. On modern microscopes, it is the smaller diameter knob that is usually concentric to the coarse knob. The fine focus knob raises and lowers the stage delicately in minute steps and becomes the final control when focusing the image through the oculars and camera. Frequently, the fine focus knob's rim has tick marks that indicate the movement of the stage in microns. Typically, one full rotation of this control will move the stage 100 microns, or 0.1mm (Fig. 4).

Above the stage, closest to the specimen, is the objective lens. Its name reflects its position in the optical path, as it is closest to the object being examined. As with the microscope eyepieces, the magnification of each objective lens is engraved on its barrel as a number followed by an x. Usually there are several objectives mounted on the microscope, and since they have different powers, they are rotated under the eyepiece to vary the magnification. They are mounted on a circular rotating disc called the nosepiece. The nosepiece can carry as few as two objectives and as many as six.

Below is a listing of the microscope components. We will use these terms in our figures. These components have been around for many years. They can be found in a variety of microscopes, from an instrument as old as those having a horseshoe base with an inclination joint, to those instruments with a built-in illuminator.

* **Coarse focus knob:** The knob quickly positions the stage so that the subject is in approximate focus. The control may be sufficiently delicate that the 10x or lower power lens can be focused. It is for moving the stage several millimeters
* **Fine focus knob:** The knob that delicately changes focus. It is used after details of the subject are seen in the eyepiece. Typically one rotation will move either the stage or the microscope head by only 0.1mm. This knob is smaller in diameter than the coarse focus knob
* **Stage:** The flat plate on which the slide is mounted
* **Mechanical stage:** The geared controls that move the specimen across the surface of the stage
* **Objective lens:** The imaging lens of the microscope, and the one positioned closest to the object being observed. A number engraved on its side indicates its magnification
* **Nosepiece:** The circular disc that holds multiple objectives and functions to change objectives rapidly
* **Trinocular head:** The three-tube body above the nosepiece that holds the two eyepieces for visual observation, and the photographic tube for the camera
* **Eyepiece:** The lens closest to the observer's eye. It is engraved with its magnification, and multiplying this value by the number of the objective lens gives the total visual magnification

These parts are the essential components of any modern microscope. Knowing where and how to use them enables the microscopist to improve the chances of recording excellent images. As mentioned earlier,

Köhler illumination is required for accurate imaging.

Köhler Illumination

Identifying Parts Needed to Obtain Köhler Illumination

The following section describes the microscope parts used to obtain Köhler illumination. They will help familiarize the new user as to which controls should be adjusted.

Field diaphragm: The iris diaphragm whose diameter controls the area of the specimen that is illuminated. This is found beneath the condenser and is usually by a knurled knob surrounding the opening at the base of the microscope where light comes out.

Condenser: This sits between the stage and the base of the microscope. It has lenses for focusing light on to the specimen.

Condenser focus knob: The knob raises and lowers the condenser. It is found beneath the stage at the level of the condenser.

Condenser centring screws: Two opposed screws that centre the condenser to the objective lens. These are found on the platform that holds the condenser. In some microscopes these controls are not present. Instead the condenser is mounted in a ring with a single knob that tightens a clamp for retaining the condenser.

Condenser diaphragm: The iris diaphragm is located either between the two lenses of the condenser or beneath the bottom of the condenser lens. It controls the cone of light projected to the specimen.

Instructions for Obtaining Köhler Illumination

Step 1: Turn on the microscope illuminator and make sure light is passing through the field diaphragm.

Step 2: Place a slide (a stained section of animal or plant tissue is best) on the microscope stage. Secure the slide with the microscope's clips making sure the cover glass is facing up. Rotate the objective marked 10x into position. Make sure it will clear the clips that hold the slide before rotating it into place. When the objective is properly positioned, it will be perpendicular to the stage.

Step 3: Using the coarse focus knob, move the stage towards the 10x objective so it is close, but not touching the lens' front surface. Be careful not to hit the objective into the slide. You should now be able to see an out-of-focus specimen.

Step 4: While looking through the eyepieces, turn the coarse focus knob so that the stage lowers (moves away from the objective) to bring the specimen into rough focus. Lowering the stage ensures that you won't damage the objective by hitting the slide or stage clips.

Step 5: Once the image is roughly in focus, adjust the fine focus knob until the image appears sharp (Fig. 5).

Step 6: Close the field diaphragm to its minimum diameter. You should see a brightly illuminated spot. Its limit is the edges of the field diaphragm, and generally the edges will appear blurred (Fig. 6).

Step 7: Adjust the condenser focus control until the edges of the field diaphragm become sharp. When this is accomplished, the image of the field diaphragm is projected on to the specimen plane (Fig. 7).

Step 8: Open the field diaphragm until it just clears the field of view. This ensures that only the region being viewed by the microscope is illuminated (Fig. 8). If more than this is illuminated, light scatter from regions outside the field of view may reduce contrast.

Step 9: If the field diaphragm is not centred in the field of view, use the condenser centring controls to centre it.

Step 10: Remove one of the eyepieces and look down the tube of the microscope. Open and close the condenser diaphragm, watching how the circle of light increases and decreases in diameter. Reopen the condenser diaphragm and observe the maximum size of the illuminated circle. Then, noting this position, close the condenser diaphragm so that the diameter of the lighted circle is three-fourths (75 per cent) that of the widest field (Fig. 9). For stained samples, these settings provide the optimum image for revealing fine details while maintaining contrast. If you close the condenser diaphragm to its minimum diameter, the contrast of the image increases at the expense of losing fine detail. If you open it too wide, the image loses contrast, and subtle structures disappear in the glare.

Step 11: To increase magnification, rotate the objective with the next highest number into the optical path. Again, make sure the objective clears the slide and stage clips to avoid scraping and damaging the objective. Instead of viewing through the oculars, watch the objective while moving it into position. This will prevent any damage to the objective that would make it unusable. Repeat operations from Step 6 through to Step 10.

The above list describes how to obtain Köhler illumination. To the uninitiated it may appear overly complex and a needless exercise. But the operation is really straightforward, and following the above steps ensures that you get an image that is bright, evenly illuminated, and of high contrast.

The first step is, of course, to get the specimen in focus. This serves as the baseline for optimizing the illumination system. When it is focused, the condenser is adjusted so as to concentrate its light on to the specimen by focusing the field diaphragm on the same visual plane. After the light is focused, the field diaphragm is closed to ensure the area being lit is limited to what the microscope 'sees'. If this is not done, the specimen loses contrast as the light outside the region being studied can enter the objective and cause a slight glare.

The condenser iris diaphragm serves to adjust the cone of light entering the objective. This can be envisioned as a base that sits at the top of the condenser and whose apex is at the specimen. Then the rays of light cross at the level of the specimen and they arise, forming another cone whose base reaches the objective lens. If the diameter of this cone is too large, light contrast is decreased. Closing the condenser iris diaphragm narrows the cone and ensures its top base is contained and is perhaps smaller than the diameter of the front objective lens. A subtle point which is not apparent is that the diameter of this cone controls resolution. The wider the cone, the higher the resolution that can be obtained. However, if the cone is so large that it exceeds what light can directly enter the objective, glare can be created. And vice versa, if the cone

Fig. 5 The image of the specimen is brought into focus.

Fig. 6 Closure of the field diaphragm to its smallest position. In an unaligned condenser it is off-centre and the edges of the field diaphragm are out of focus.

Fig. 7 The condenser is brought into focus by focusing the edges of the field diaphragm until their edges are sharp.

Fig. 8 The field diaphragm is centred and opened just short of the edge of the field of view.

Fig. 9 The view down the tube of the microscope without the eyepiece. The edges of the condenser iris can be seen, and are adjusted so that the bright circle is about 75 per cent of the diameter of the edge of the objective.

is too small in diameter, it can obscure fine detail.

The majority of the objective lenses work in air, and are described as being 'dry'. However, there is a class of objectives that are designed to work with a liquid medium between the cover glass and the objective lens. These 'wet' lenses are dipped in an optical oil and are referred to as 'oil immersion objectives'. To use these lenses, a drop of oil is applied to the top of the cover glass and the objective lens is lowered into it. There are two ways this is accomplished. You can lower the stage to apply the oil, and then carefully raise it to bring the object back into focus. This is risky when using older microscopes which do not have the objective protected with a spring-loaded mount, as an overly exuberant operator can crash an objective into the cover glass. On recent models of Olympus microscopes there is a locking clamp, and once you are in focus with the 40x objective, you apply the clamp to the coarse focus. When set, it allows you to lower the stage but you can only raise it to the point you set the focus clamp. To apply oil, lower the stage after it has been set, apply the oil, and then raise the stage until it stops. This returns the objective to near focus, which can then be adjusted to perfection with the fine focus knob.

Another way of immersing an objective is to swivel the dry lens out of the light path by rotating the nosepiece. Then place a drop of oil on the slide and rotate the oil immersion lens into position. A modern microscope is designed to maintain approximate focus when rotating its objectives into position. That is to say, if the microscope is in focus when using its 40x objective, it should be nearly in focus if you rotate its oil immersion lens into position. This design feature is described as being parfocal. However, this is only applicable if the objectives are from one manufacturer.

Using oil immersion lenses is inconvenient because the objective lens and slide have to be cleaned. This is annoying if you wish to go back to a lower power and use a dry objective. If you are working with live samples in water, it is nearly impossible to switch from oil to a dry objective. An oil immersion lens should be regarded as the last lens to be used when studying a sample. When examining a specimen it pays to start with an objective of no more than 10x, and then proceed up the magnifications. We try never to use an oil immersion lens until after the specimen has been studied with a dry 40x objective.

One point about using oil immersion lenses is that they cannot achieve their full resolution unless the condenser is 'oiled' to the bottom of the slide. This means a drop of oil has to be added to the top of the condenser lens so that it is in contact with the bottom of the slide. If you do not do this you will see a variation in Step 11 in the section describing how to achieve Köhler illumination. When you open the condenser iris, it will stop before it reaches the diameter of the oiled objective lens. To go to the edge of the objective lens, you will have to oil the condenser to the slide. To do this, lower the condenser, apply a drop of oil to the top of the condenser top lens, and then raise the condenser until the oil contacts the bottom of the slide. The condenser is then focused as described in Step 7. Before doing this, make sure the top lens of the condenser is designed for oil immersion. This will be shown if it has a number 1.0 or greater inscribed on the metal mount surrounding the top lens. If the number is less than 1.0 don't bother oiling it since the condenser is not designed for this application.

Oiling the condenser is not a task to be undertaken lightly because doing so imposes an additional cleaning step. Also, oiling the condenser limits how far you

can move the slide. If the slide is moved so that it is sliding across the surface of the stage plate, most annoyingly oil wicks up between the bottom of the slide and the top of the stage plate, and when this occurs, the slide cannot be moved as the viscosity of the oil anchors it. Some of the best mechanical stages were designed so the slide would not be dragged across its surface. Instead, the rack and pinion would move the entire plate. We do not know of any modern microscope which has such a sophisticated stage design.

Having said this, we would add that oiling the condenser is not usually practised in the modern research laboratory. Because of its inconvenience, many researchers simply use the condenser dry, even if it is designed for immersion work. Although there is a small sacrifice in resolution, it is acceptable for routine work. As a consequence, the manufacturers have designed condensers with interchangeable top elements in the form of caps that screw on. These will allow the condenser to have either a numerical aperture greater than 1.0, or a numerical aperture less than 1.0. In other words, the 1.2 (or larger) cap is designed for oil immersion work, while the 0.9 cap is for 'dry' work. As noted earlier, many researchers choose the 0.9 cap. This is important because some accessories, such as phase rings and differential interference contrast prisms, are designed to work with either one or the other cap, and if you attempt to use the accessory with the incorrect cap, you will get inferior results.

As a quick aside, there are long working condensers whose aperture might be 0.6 or lower. These units are designed to increase the distance between condenser and specimen. Such condensers are most commonly used on inverted microscopes when the subject comprises cultured cells grown in culture dishes.

Troubleshooting

This chapter should be sufficient to allow the neophyte to illuminate a specimen properly for viewing and photography. However, things don't always work as planned. The following will help you troubleshoot any problems that may arise.

No light emanates from the field diaphragm

Tungsten and metal halide lamps have a rheostat for varying light output. When this is set at the lowest value, the bulbs do not emit light, so make sure the rheostat is set to above the minimum value. Also, some transformers have a rheostat for controlling intensity, and an on/off switch for providing power. Make sure the power switch is set to on. If this does not help, the next step is to remove the bulb and

MAXIMIZING THE LIFE OF A TUNGSTEN BULB AND REPLACEMENT BULBS

If you want to get the longest run times with a filament bulb, here are a couple of suggestions. First, you adjust the rheostat so you use a voltage less than that required for the bulb. If you can use a lower voltage, the filament light is extended. Second, a variable rheostat helps to preserve the bulb. Start it up at a low voltage and then gradually increase it until you reach the operating voltage.

If you need to replace the bulb you may be in for a search and an expensive purchase. We have found that the 8V 5A bulb for the Tiyoda microscope is no longer manufactured. One vendor offered to sell the bulb to us for £75! You may wish to get a replacement LED light source; these can be purchased from online vendors. For our Leitz Ortholux 1, we purchased a LED from www.retrodiode.com, who sells on eBay. His illuminator output is much higher than that provided by the 6V 5A. It is approximately 90 per cent the intensity of a 12V 100W quartz halogen bulb. This height of intensity is not needed for brightfield work; however, if you use a Heine condenser this additional light will facilitate using this phase contrast condenser.

Retrodiode sells replacement lights for various models of Zeiss, Nikon, Leitz, Leica, Olympus, AO, Bausch and Lomb, and Wild microscopes. These replacement lights replace the bulb of these microscopes' regular illuminators.

inspect the filament with a 10x loupe. Sometimes an extremely fine break in the filament is the cause for failure.

Some microscopes have insertable filters in their base. This is a convenient way to insert neutral density filters. If the bulb is glowing, make sure these filters are not blocking the light path. On occasion these may not be fully in position, and the frames for the filter are blocking the light.

Light emanates from the field diaphragm but not from the condenser

Light is being blocked at the condenser. This can occur if there is a swing-out filter holder at its base: if not positioned correctly, its frame can prevent light from entering the condenser. With some of the older condensers, their iris diaphragm may be adjusted off-centre. If this is the case, you need to centre the iris.

The modern 'universal' condenser has a large disc for mounting Wollaston prisms or phase rings. If the disc is positioned incorrectly it prevents the light from passing through the condenser. With these condensers, you need to make sure they are positioned so that the aperture designed for brightfield imaging is in position (Fig. 10).

Light passes through the slide but there is no image in the eyepieces

Check to ensure that the objective is properly centred. When the nosepiece is rotated, there should be an audible click when a new objective is placed in the optical path. If the objective is not properly positioned, it may block the light. If the objective is in position, the problem may be in the microscope head. Many trinocular heads have a prism that directs 100 per cent of the light to the eyepiece or 100 per cent to the camera. Make sure this prism is positioned to direct light to the eyepiece. Finally, if the microscope head has a magnification changer, make sure it is set to allow the transmission of light.

Conclusion

Knowing the names of the microscope controls and what they do is important for getting the sharpest image with that instrument. Of primary importance is knowing how to manipulate the controls so as to achieve Köhler illumination. This is critical if you wish to achieve the maximum quality image for photography. Setting up the microscope to use this type of lighting should be a routine for every microscopist. Although its advantage may seem minimal when working with low powers, such as 40x to 200x, its benefits become clear when working at 400x and higher. It ensures the photographer will have a uniformly lit field to photograph, and provides an image with the highest possible contrast and definition.

Fig. 10 A universal style of condenser has a large internal disc for holding optical elements. It is wider in diameter than a condenser designed just for brightfield work.

CHAPTER TWO

MICROSCOPE PARTS IN GREATER DETAIL

Chapter 1 introduced microscope controls and described how to set up Köhler illumination. These basic skills will help to start taking good photographs: however, to obtain the best results it is desirable to appreciate the finer points of imaging and optics. In part this is needed for you to know how to modify the condenser diaphragms to display the best compromise between contrast and resolution. As a microscopist, you will look at a variety of specimens. Some will be stained with colourful dyes that impart contrast. Others, such as living protists, will have less contrast. With these you will need to be able to accentuate their contrast so you can study their structure. In short, you will need to know how to adapt the illumination to the specimen.

Simple Microscopes

To gain an appreciation for the precision of microscope optics, it is easiest to work with the most basic instrument: a simple microscope. This is made up of only one lens. A reading glass used to enlarge fine print can be considered a 'simple microscope'. Typically simple microscopes are used at low magnification, and the highest power that can be used comfortably is about 10x. At these moderate powers, a user of these instruments can become familiar with the problems afflicting those who have to work with high magnifications.

Surprisingly, even for such a simple device, it is possible to use them incorrectly. For low powers, as when using a reading glass, the magnifier is held several inches from the eye. If the diameter of its lens is large enough, both eyes can be used to study the specimen. This is quite convenient and very comfortable. However, for working at higher powers, such as 10x, it is best that the lens is placed close to the eye. This gives you the largest field of view, and details will be sharp from the centre to the periphery. If the loupe is placed inches away from the eye, the viewed area is much smaller and its edges will be distorted.

A 7x or 10x loupe is a handy accessory. Having said this, there are disadvantages with working with such simple devices. Firstly, the specimen is about 1cm away from the front of the lens and often you will have to contort your body to study the sample. Secondly, if you wish to have more magnification, as achieved by using a 15x or 20x loupe, it becomes difficult to focus and hold the lens steady. The slightest departure from the correct distance for sharp focus will blur the view. Holding the lens motionless becomes more difficult as hand tremors are magnified. Bracing the hand against a solid support will help steady the lens and maintain sharp focus. Even with these simple instruments, proper technique is essential to get the best results.

Fig. 11 Ray diagram of a simple lens being used as a hand magnifier.

MICROSCOPE PARTS IN GREATER DETAIL

A reading glass is a low power magnifier that uses a biconvex lens: this is a clear disc made of either plastic or glass with a convex surface on both sides. The optical axis is the line that passes through the centre of curvature of the lens. Parallel light rays travelling along the direction of the optical axis pass through the lens and converge at a point on its opposite side. This is defined as the focal point, and its distance from the lens defines its focal length. In the case of a symmetrical biconvex lens – a lens having the same convexity on each side – there will be two focal points equidistant from the lens.

If you take a biconvex lens and place it close to an object so that it lies within its front focal point, you generate an image of the subject from light reflected from its surface. This is seen when looking through the opposite side of the lens (Fig. 11). When viewed in this way, the subject appears enlarged and right side up. Even at this low power, a critical observer can see optical artefacts. One such is chromatic (colour) aberration, which is when a border displays colour fringes, a defect caused by the lens acting like a prism. White light is a composite of all the colours of the rainbow, where each colour corresponds to a specific wavelength of light. When white light passes through a lens or a prism, it separates to its component colours as the different wavelengths are bent to differing degrees. Thus, a lens will bring the red light rays to a more distant focus point than the blue rays, and this creates a colour fringe at the borders of the subject (Fig. 12).

This defect can be corrected by using a lens that consists of two types of glass with different optical properties. Such a lens is described as being 'achromatic'. In the case of the lower-powered reading glass the colour fringes resulting from chromatic aberration are not sufficiently large to disturb most viewers. However, at higher magnification, the subject's fine borders will show these colour fringes and will detract from the appearance of the image.

An example of an achromatic loupe is the Hastings Triplet Magnifier. Superficially this looks like a single lens, but it is really a composite lens made up of three elements cemented together. In this manner, the magnifier corrects for chromatic aberration and improves the optical quality of the image by rendering the specimen's borders without the colour fringes.

High quality magnifiers, such as the Hastings Triplet, are a worthwhile addition to any photomicrographer's arsenal. They will be used to evaluate specimens before using higher power examination with the microscope. Their portability and simple construction allows them to be taken into the field, and if one is collecting specimens, a preliminary evaluation of the abundance of the harvest can be made immediately.

Fig. 12 View through a simple lens. The red and blue fringes on the edges of the blind are caused by chromatic aberration.

Compound Microscope: In General

Simple microscopes are a convenient tool for low magnification work; however, at high powers they are uncomfortable to use. To remedy this, the compound microscope was invented. Rather than use just one lens to magnify the object, two different lenses are

used: the lens closest to the object is the objective lens, while the lens close to the eye is the eyepiece lens. Initially when this instrument was invented it was more convenient to use, but it was not as optically sharp as the simple microscopes. In his tome *Micrographia*, Robert Hooke noted the inconvenience of using a simple microscope at high power, and found it advantageous to use the less sharp compound microscope. In those days, the early compound microscopes produced images inferior to the best simple microscopes, but their ergonomic design facilitated prolonged observation, and the earliest microscopists appreciated the value of repeated and prolonged study to elucidate the fine structure they were studying.

Compound Microscope: The Objective Lens

The critical component of the compound microscope is its objective lens. It is the one closest to the specimen and projects a real image upwards. This is accomplished by placing a subject on one side of the lens so that it lies outside its front focal point. The real image can be projected on to a sheet of paper. It is inverted, unlike the virtual image which is upright and cannot be projected. A second lens (eyepiece) magnifies this real image further. This is the optical basis of the compound microscope. Each lens provides magnification, and the effect is multiplicative so a 10x objective when combined with a 10x eyepiece generates an image of 100x. We had mentioned chromatic aberration. This defect becomes more objectionable as one views the specimen at higher magnification. In the case of the compound microscope, the major correction for this optical defect occurs within the objective lens.

The least expensive objective lenses are achromatic (without colour), and are designed to bring blue and red light to a common focus. In spite of its name, an achromatic lens does not remedy all colour errors. When a lens brings the two extreme wavelengths, blue and red, to a common focus, there are still colours with wavelengths longer than 490nm and shorter than 600nm that are not brought to the same focus. This situation is described as residual chromatic aberration. To correct this, there are two additional classes of objective: the semi-apochromats and the apochromats. Both of these designs require using more lenses and expensive optical elements, such as fluorite.

When Ernst Abbe designed these lenses, they were to bring three wavelengths to the same focal point: blue, 490nm; green, 550nm; and red, 600nm. Some of the objectives will have 'plan' in front of their name. This indicates that they are designed to provide a flat field image to the eye or to the camera. Most objectives will exhibit a curved field so that when the centre of the image is sharp its periphery is not. Plan objectives correct this deficiency and provide an image where its periphery and centre are sharp. This is an advantageous feature if one wishes to record the maximum field of view with a camera.

Modern objective lenses have improved on early designs, and today, a modern achromatic lens made by Nikon, Olympus, Leica or Zeiss can focus three colours to a common point, and an apochromatic lens can focus four or more wavelengths to a common point. Many of the developments in modern objective lens design reflect the advances in computer-aided design and improved optical glass. Today, a modern objective used for two-photon microscopy is required to focus 1,000nm (infrared) light and generate

Fig. 13 Light passing through the periphery of a spherical lens is focused at a further point than light that passes through its centre.

images with 405nm (violet) light.

Another optical defect is spherical aberration (Fig. 13). This is a failure of a lens to bring parallel rays of light to a common focus. The rays passing through the periphery of a lens are brought to a different focal point than those rays passing through its centre. Images viewed through a lens with spherical aberration appear 'soft' and lack contrast. Using multiple lens elements and aspherical ground lens surfaces helps to correct this defect.

The objective lens design and quality determine the projected image's sharpness. An understanding of its optics and specifications enables you to determine the most appropriate magnification for visualizing the specimen. The first concept we will investigate is calculating the limits of seeing fine detail with a microscope. Microscopists have an equation to determine the minimum distance that can be resolved by an objective lens. This equation has three variables: the angle of light captured by the objective, the medium that lies between the objective and the specimen, and the wavelength of light that illuminates the specimen.

A microscope's ability to resolve and distinguish fine detail depends on its ability to gather a wide cone of light. Specifically, this is referred to as its 'angular aperture', and a lens can have a varying angular aperture depending on its diameter and its closeness to the object. The greater the angle of light the objective can receive, the greater its potential for discerning fine details. This variable is expressed as the half angle of light (Fig. 14) accepted by the objective lens (θ).

The second variable is the medium between the specimen and the objective lens. When light moves through a transparent material, its speed is diminished; this reduction is described by the medium's refractive index (n). The n of air is 1 and therefore light's speed is unchanged when travelling through this medium. The n of water is 1.33 so light's speed is reduced by approximately 13 per cent when travelling through this medium. Similarly, the n of oil is 1.515, which results, when travelling through oil, in light's speed being reduced by approximately 33 per cent.

Taken together, the immersion medium and the angle of light are described by the term 'numerical aperture' (NA) and expressed by the following equation:

$$NA = n\sin\theta$$

The angle θ can range from 0 to 90º and therefore sin ranges from 0 to 1. Theoretically, a dry objective will have a maximum NA of 1.0 since the sin 90º is one, and the index of refraction (n) of the medium between the objective lens and the slide, in this case air, is 1.0. Practically this will not be achieved, and the largest NA for a dry objective is 0.95. Every objective has an NA value inscribed on its barrel ranging from 0.01 and 1.40. In Fig. 14, objective A has a smaller NA than objective B.

An objective lens's NA can be greater than 1. These larger values occur when interposing a liquid, usually water or oil, between the specimen and the front element of the lens. Such liquids will have an n greater than 1.0. In the case of oil (where n is 1.515), and when it is inserted between the specimen and the

Fig. 14 Ray diagram showing two cones of light projected to two objective lenses. The larger cone is for an objective lens with a larger numerical aperture.

objective, the NA equation becomes 1.515sinθ. When using water (where *n* is 1.33), the NA equation becomes 1.33sinθ. In both cases this will generate an NA value greater than 1.

The final variable for determining the resolving power of the lens is the wavelength of light used to image the sample. Daylight appears white; however, it is possible to break it up into its component wavelengths by passing white light through a prism. This was demonstrated by Newton, who showed that white light is composed of colours ranging from violet to red. The equation for calculating the resolving power of the lens is as follows:

MRD=0.61λ / NA

MRD stands for 'minimum resolved distance', and represents the minimum distance between two objects where they can be distinguished as being separate. The expression λ is the wavelength of light, and NA is the numerical aperture of the objective.

In the case of MRD, the smaller its value, the better the resolution. This formula indicates that resolution improves if you reduce the wavelength of light, or if you use a lens with a higher NA. For the purposes of illustration, assume that λ is 0.550μ, a wavelength of light that appears green to the eye. When you're using an objective with an NA of 0.95, its resolving power is 0.35μ. If you use the same lens and illuminate the specimen with blue-violet light (0.425μ), the resolution improves and you should be able to resolve to 0.26μ. The improved resolution is from 0.35μ to 0.26μ. If you replace this lens with one that has an NA of 1.4 and uses 0.55μ for illumination, the resolution is 0.24μ. However, if you go all out and use the NA 1.4 lens with blue-violet light, the MRD is 0.19μ. Thus, selecting a lens with a greater numerical aperture, or using a shorter wavelength of light, or both, allows you to see finer details.

The reader may wonder why we are expressing these terms in microns rather than nanometers. This will be revealed when we describe in Chapter Five the equation to determine the pixel size needed to obtain a certain degree of resolution. In that chapter we provide a formula for determining pixel size based on the camera lens's NA. Since the pixel size in cameras is expressed in microns, we used those units for specifying wavelength.

If the goal is to obtain the highest resolution, you need to use a lens with the largest numerical aperture, and work with monochromatic light of shorter wavelengths.

Viewing the Specimen

Although it seems counterintuitive, the image seen through the microscope is not a direct representation of the subject being observed. Light interacts with the system, and its wave-like property is responsible for image formation. Light rays can bend, interact with other light rays, and react to obstacles in their path. Light also interacts with the specimen on the microscope's stage as it passes from below, travelling through and around the specimen. The objective, eyepiece and mounting medium, to name a few components, all play an integral part in how the image appears.

The following experiment by Ernst Abbe demonstrates how light rays bend and interact with each other to form the image seen through the eyepiece. In addition, his studies demonstrated the role of numerical aperture on resolution. For a test specimen, Abbe used a grating with a regular pattern of opaque

Fig. 15 The back of an objective lens showing the zero-order, first-order, second-order and third-order diffraction spots. The slide's grid bars are spaced at 10 micron intervals.

bars separated by clear spaces. He showed that the objective lens generates a diffraction pattern that can be observed by removing the microscope's eyepiece and looking down its optical tube. If you do this, you can see the circular border of the back of the objective lens, a bright spot (uncoloured) in its centre, and a series of coloured spots extending from the centre spot (Fig. 15). The bright spot is direct light passing through the specimen. The coloured spots arise from light diffracted by the border of the grating.

The bright centre spot is the zero-order spot and is composed of light originating from the light source that passes through the grating and does not interact with its borders. In contrast, the coloured spots immediately surrounding the bright centre are the first-order spots. As you go outwards, the subsequent sets of spots are numbered second-order, third-order, and so on. The coloured spots represent light interacting with the grating. As the light rays pass the edges of the grating, their path is bent and they radiate in a fan-like pattern (diffraction). These rays carry information on the spacing of the grating. If you have more bars closer together, the coloured spots spread out laterally. If the bars are separated by a greater distance, the diffraction spots do not spread out as far. This phenomenon is based on the wave nature of light. The interaction of diffracted light rays from neighbouring edges of the grating creates the coloured spots.

As the specimen becomes more complicated, for example a pattern of pores in a diatom's frustule, the diffraction pattern changes. In the case of a regular lattice of tiny pores, the diffraction pattern can appear as a central spot with six coloured (first-order) diffraction spots spreading out in a hexagonal pattern (Fig. 16). A good subject to reveal this pattern is the diatom Pleurosigma: when viewed with a 40x objective and a 10x eyepiece, you can see the fine pores in the silica skeleton (Fig. 17). If you remove the eyepiece and look down the microscope tube, you can see the first-order diffraction spots that surround the zero-order spot. If you can alter the objective lens so that it has an NA of only 0.6, you will see only the bright central direct spot in the back of the objective lens (Fig. 18). When this occurs, you will see, when you replace the oculars, a diatom frustule without its pores (Fig. 19).

Fig. 17 The diffraction pattern of a diatom's pores.

Fig. 16 The pores of the diatom that generated the diffraction spots.

Fig. 19 Closing the objective's aperture with an internal diaphragm blocks the first-order diffraction spots.

Fig. 18 The loss of the first of the first-order spots prevents the visualization of the pores in the diatom frustule.

This illustrates the role of NA for resolving fine structure.

Figs 16–19 were made with a Zeiss Planapo 40x objective with an NA of 1.0. It has an internal iris diaphragm that reduces the objective's NA from 1.0 to 0.6. When its iris is set to NA 0.6, it blocks the light rays that form the first-order diffraction spots from entering the lens. By opening the iris so the lens's NA is set to 1.0, the light rays forming the first-order diffraction spots can enter the lens.

Viewing the specimen and correlating its appearance to that of the diffraction spots demonstrates the interaction of the specimen with the illuminating light. Altering the collection of the diffraction spots will change the appearance of the image seen through the eyepiece. This is most dramatically evident when Abbe showed the appearance of virtual grating bars by manipulating the relationship between first- and second-order diffraction spots. A coarse grating can generate first- and second-order diffraction spots. However, if the objective lens is modified so the first-order diffraction spots are blocked while allowing the second-order diffraction spots to go through, a surprising event occurs: the number of bars seen in the eyepiece is doubled. The image now matches what would have occurred if only one set of the diffraction spots were captured by the objective lens. The appearance of these 'virtual' bars is a result of manipulating the diffraction spots collected by the objective lens. Remember, bars closer together have their diffraction spots further apart. Thus blocking the first-order diffraction spots so that only second-order spots are captured, creates the appearance of virtual bars. This shows that the interaction of these diffraction spots influences the image viewed through the eyepiece.

Understanding how diffraction spots are collected helps to explain why an objective with a higher numerical aperture can see finer detail than one with a lower numerical aperture. A lens that can accept a wider cone of light captures more of these interactive spots, while a lens that fails to capture them misses the fine detail that they convey.

Dry Objectives and the Rationale for Immersion

The first objectives were used dry, meaning the space between the specimen and the lens was air. However, it was discovered that filling this space with a fluid improved the light-gathering ability of the objective and increased image contrast. A variety of liquids can be used for this purpose, but today the most popular is an oil whose optical characteristics match that of glass. To appreciate the advantages of using an oil immersion objective, you must remember two things. First, as discussed in the previous section, the more light rays an objective can collect, the greater its potential resolving power. The second is that adding oil between objective lens and coverglass allows more light rays to be collected. To appreciate this, you must see what happens when light passes through the glass-air interface.

When the angle at which light encounters the glass is varied, its rays either pass through the glass or are reflected down at the glass-air interface. The angle when light is reflected is called the critical angle: thus if the light rays' angle is less than this critical amount, the light ray goes through the glass-air interface. But if the angle is at the critical amount or greater, it will

Fig. 20 The light rays (the left side of the diagram) are bent by the glass-air interface; placing oil between the coverglass and objective (the right half of the diagram) prevents this.

not pass through the glass into the air: instead, it never leaves the glass and is reflected back into the glass. This is illustrated in the left half of Fig. 20.

It is possible to capture these reflected rays by interposing a fluid between the top of the slide and the objective lens. Typically this is an oil whose index of refraction is the same as glass, and the light rays travel in a straight line through the coverglass and enter the objective lens. This is shown in the right half of Fig. 20.

Depth of Field

Depth of field is the extent to which the subject is rendered sharply along its vertical or optical axis. A large depth of field has a greater zone of sharpness than a narrow depth of field. In microscopy, the zone of sharpness is so narrow that the image appears to be two-dimensional. In fact, the view obtained with a high NA objective is described as an optical section. As one seeks to increase lateral resolution the depth of field becomes narrower. To understand visually the structure's three-dimensional appearance a microscopist will continually use the fine focus to visualize different planes of a thick specimen. Photographically, software is used to extend the microscope's depth of field. This is accomplished by taking pictures at different heights within the specimen, and then stacking them together in the vertical axis.

The Role of the Condenser and Field Diaphragms

Proper illumination requires that the condenser concentrates the illuminant's light on the specimen, and this entails proper focusing of the light on to the specimen. If light is not properly directed, it will create glare and reduce the contrast of the image. In Chapter 1, we describe how to obtain Köhler illumination. This form of illumination is used in all modern research microscopes, and it was developed to ensure the field of view had a uniformly even brightness when viewing the specimen. Its development was needed because tungsten bulbs use a coiled filament, and this created an unevenly lit field of view because it is an inhomogenous light source.

This was noticeable when Nelson illumination was used. This type of illumination is obtained by first establishing the optical plane of the specimen by viewing it through the eyepiece and adjusting the focus so the specimen appears sharp. This ensures you are focused on the specimen plane. Next, by raising and lowering the condenser, you can see the light source and focus its image on to the specimen plane. When the image of the illuminant is superimposed on the specimen, its light is maximally concentrated on the subject. In the 1800s, an oil-lamp flame served as the indoor light source. The lamp was placed in front of the microscope, and a substage mirror was tilted to direct the light towards the bottom of the condenser. Since a broad flame generates a wide image, the subject was evenly illuminated when the flame was projected on to the specimen plane.

This situation changed when electrical light sources became available. A light bulb has a coiled metallic filament for generating light. Compared to the size of a flame, these filaments are narrow coils of wire, and when the condenser focused their image on to the specimen plane, they could be seen as glowing coils within the specimen. This creates an uneven field of view.

A homogenous light source is needed to provide an even field of view, and one way to achieve this was with the ribbon filament bulb. Rather than using coiled tungsten, this light source, known as source-focused illumination, used a ribbon-shaped rectangle, 2 x 8mm in size. This bulb provided a uniform field of illumination when focused on to the specimen at very high powers. Edward Nelson was a proponent of this simple and inexpensive type of lighting.

Today, instead of the ribbon filament, all you need is a frosted light bulb and a microscope with a mirror for directing the light to the condenser. Place the frosted light bulb in front of a microscope and aim the mirror so that the bulb's light is directed up towards the condenser. Then take a slide and focus on it using a low-

power objective lens. When you have a sharp image of the subject, raise and lower the condenser focusing controls until the image of the light source is focused on the specimen. The slight imperfections on the bulb's surface can be used for focusing it on to the specimen plane. These imperfections can be thrown out of focus by slightly mis-focusing the condenser.

The major disadvantages of source-focused illumination is that it generates flare, and the image may have reduced contrast. A bulb with a frosted surface illuminates a much larger area. As a consequence, some authors recommend using an iris diaphragm in front of the bulb to limit the area of the illuminant. Today, the majority of microscopists use Köhler illumination.

Köhler illumination provides an even field of light, and is employed in some form by all microscope manufacturers on virtually all their microscopes. Like source-focused illumination, Köhler first requires that you focus on the specimen. Then, using the specimen plane as a reference point while viewing through the eyepiece, raise and lower the condenser until you see the image of the field diaphragm. The field diaphragm defines the area of the slide being illuminated. Condenser focus is achieved when you focus the edges of the field diaphragm. To minimize glare, open the field diaphragm so that its edges just clear the circular field seen in the eyepiece, thereby ensuring that light is limited to the field in view. If the diaphragm is opened too much, the illuminated field extends beyond what is being observed and image contrast is reduced.

In both source-focused and Köhler illumination, the goal of focusing the condenser is to generate a cone of light that fills the numerical aperture of the objective lens. Since the condenser's cone of light is adjustable by opening or closing its iris diaphragm, it permits a single optical condenser to serve a variety of objectives, each having its own numerical aperture. Closing the condenser iris forms a narrow cone of light, suitable for a lens with a small numerical aperture. Opening the iris forms a wider cone of light, suitable for a lens with a larger numerical aperture. Opening the iris and using a cone of light greater than the objective can receive will reduce contrast by creating flare.

You can evaluate how much light the condenser is sending to the objective by removing the eyepiece and peering down the empty tube. When you do so, you will see a bright circle of light. The diameter indicates how much of the objective's aperture is being filled with light. The diameter of the light is controlled by the condenser iris. It will enlarge or shrink when you open or close the condenser iris. Ideally, this light should appear to fill the rear aperture of the objective. On a well-stained specimen, the best objective lens can have 90 per cent of its aperture filled with light (Fig. 21) with no noticeable loss of contrast (Fig. 22).

Fig. 22 A stained preparation observed with a full numerical aperture of the condenser.

Fig. 21 The view of the rear of the objective with the condenser iris set to 90 per cent of the objective's NA. This is suitable for stained preparations exhibiting deep colours.

Many microscopic objects are colourless: they are transparent and their internal structures do not absorb light. In other words, when light passes through them, they appear clear with little contrast. This is especially true for living cells and unicellular animals, making them challenging subjects to record photographically. In many cases, microscopists increase the cells' contrast by killing them and colouring them with dyes, which stain their internal structure. Tissues prepared for histological studies are examples of this type of treatment. An organ is harvested, treated with formaldehyde, cut into thin slices, and then coloured with dyes. In the majority of cases, the cells' nuclei are coloured blue while their cytoplasm is coloured red. When this is done, the specimens will absorb light passing through them, and their finest details are seen in high contrast. This allows the operator to widen the condenser aperture so that the full aperture of the objective can fill with light.

This strategy cannot be employed when viewing living cells, diatom frustules, or the smaller protozoa, as shown in the top half of Fig. 23. When you open the condenser iris so its aperture fills 90 per cent of the objective aperture, the resultant image will look flat. To improve the image, you have to narrow the cone of light entering the objective. This will increase contrast, as can be seen in the bottom half of Fig. 23. The ease with which details can be seen is readily apparent when viewing through the eyepieces. The danger is that as contrast increases, resolution is reduced. As a practical choice, you should not close the condenser aperture to less than 50 per cent of the objective's aperture. To prevent this, remove the eyepiece and view the objective's back aperture while closing the condenser aperture.

Condensers come in a variety of configurations, and like objective lenses, they are designated as being either 'dry' or 'immersion'. The former has its top elements working in air, while the latter uses immersion oil to bridge the gap between the bottom of the slide and the top lens of the condenser. Just like objective lenses, condensers are designated with a numerical aperture: those working in oil have an NA greater than 1 (NA 1.2 to 1.4), otherwise the condenser is limited to working at a maximum NA of 0.95.

For routine transmitted light work, oiling the condenser is unnecessary. With stained slides, the loss in performance is slight, and most workers prefer working 'dry' because it is more convenient and less messy. As the slide is moved across the stage to view different areas, the oil can be trapped between slide and stage, and this can become a problem. The slide can adhere to the stage plate so that it is not easy to traverse. Moreover, there is the inconvenience of having to clean the slide when you have finished viewing it. However, those who work at the microscope's limit of resolution must oil the condenser for the finest definition. For example, in video microscope studies of subcellular organelles and microtubules, resolution is

Fig. 23 Montage of a diatom. The top half was taken at 90 per cent NA of the objective, while the bottom half is taken with the condenser aperture set to 50 per cent.

improved when the condenser is oiled to the slide. By using special contrast-enhancing techniques, and a maximally opened condenser iris diaphragm, it is possible to visualize single strands of microtubules. These protein polymers are only 25nm in width, which is about one-tenth of the limit of resolution of a light microscope imaging with green light.

Focusing: Coarse and Fine

All microscopes come equipped with a coarse focusing mechanism for obtaining focus. The coarse knob is used to roughly adjust focus. Once the specimen's outlines are visible, the fine focus is used to attain the sharpest image. Modern microscopes have coarse and fine focus mechanisms placed close to the level of the desktop. Many of the modern instruments position them concentrically. This convenient arrangement is ergonomic as the user's forearms can rest on the desktop. Also, finding the focus is especially easy when the knobs are mounted concentrically so the fine focus can be operated without having to look away from the eyepiece to identify the knob. In addition, the fine focus operates through the entire range of movement of the stage. In older microscopes, the gearing systems are separated, with the fine focus travelling only 2mm both directions. This design is to be avoided if you intend to mount a motor for controlling fine focus. If the fine focus is brought to an abrupt stop, it can damage the motor, and if the motor is powerful, the fine focus itself can be damaged.

For research that demands the highest magnification and resolution, the fine focus should traverse 100μ per rotation. Some student microscopes have a fine focus that raises or lowers the stage 400 microns per rotation. This can be inconveniently fast for high magnification work, and we prefer the slower rate – plus a slower rate is especially critical if you wish to use software for extending the depth of field. This requires taking a series of photographs at various heights by moving focus in fine, regular increments. A micron scale, which measures the vertical distance traversed when the fine focus is turned, is invaluable for this work. Such a scale simplifies the setting of focusing 'steps': for example, you can take a sequence of twenty pictures, each differing one micron in the vertical dimension.

The focusing controls of a modern upright microscope are designed to move the stage, rather than the microscope's body. This design simplifies adding a motor for controlling fine focus. In addition, the weight carried by the focusing controls is limited to the stage. If these controls had to raise or lower the body tube, the weight would vary depending on the accessories added to the microscope. Adding a camera can increase the weight by several pounds. By restricting movement to the stage, the gears carry a fixed weight and the eyepieces do not move vertically. In earlier designs, when these controls carried the weight of the body, the additional weight from mounting a camera or other optical accessories could result in the focus drifting downwards, and greater friction had to be applied to prevent this movement. This would make the coarse movement difficult to turn, and made finding rough focus more difficult.

The Stage

The stage holds the specimen and moves it in three-dimensional space. The specimen is moved vertically for focusing, and laterally to change the area being viewed. The mechanical stage, a precision gearing

Fig. 24 Close-up of a mechanical stage firmly holding a slide.

system, moves the specimen along an X/Y coordinate (Fig. 24). For biological work the stage is usually rectangular, while for petrographic or polarized light work, the stage is usually circular and can rotate about the optical axis. The most desirable stage is mounted on a concentric ring of ball bearings, as this allows it to be rotated with precision and ease. In addition, such a stage is equipped with centring screws to ensure that rotation occurs in the centre of the field of view.

For photomicrography, a rotating stage is desirable in that it allows you to control composition precisely by rotating the specimen so it is aligned to the frame of the picture. Those stages equipped with ball bearings are highly desirable in that rotation is smooth and precise.

Substage and Condenser

Simple student microscopes typically have a condensing lens glued to the bottom of the stage, an arrangement that has the benefit of simplicity. The manufacturer designs and manufactures the lens to be prefocused, which prevents the student detracting from the microscope's performance by defocusing the condenser. This condenser has Waterhouse stops: it consists of a rotating disc with apertures of various sizes drilled into it, and by rotating the disc, the different sized apertures can be rotated into the light path. Optically this is the equivalent of a condenser iris diaphragm. In this manner, the condenser aperture can be matched to that of the objective.

In contrast, laboratory and research microscopes have a more complicated design for their condensers, in that their mounts allow them to be focused on to the specimen. In addition, they can be aligned to the optical axis with a set of centring screws. There are some research stands, such as the Wild M20 and the early Nikon S-series microscopes, where the condenser cannot be centred. Instead it is mounted in a simple sleeve which is pre-centred to the optical axis. This is a disadvantage; however, it has a hidden benefit. Many of these condensers may be mounted to stands for which they were not designed: for example, Nikon condensers of that era will fit Tiyoda microscopes, and this can be handy as it may enhance the versatility of the microscope. We found that some of the early Nikon condensers have an iris diaphragm that can be shifted off-centre. In addition, the iris can be rotated 90 degrees to provide a flexible way to obtain oblique illumination. Admittedly it is a bit of a gamble when mixing and matching microscope parts; however, this is one of the fascinating experiments a microscopist can undertake. Those microscopes with centring condenser mounts used a proprietary design which discourages such experiments.

The basic interchangeable condenser is the two-lens Abbe, which is not corrected chromatically or spherically. Frequently this condenser has a removable top lens that can be taken off by unscrewing or, more conveniently, via a lever which pivots the lens out of the optical axis. More advanced condensers are corrected for chromatic and spherical aberration, and these condensers are desirable for high resolution imaging. Being colour-corrected, the colour fringes forming from the field diaphragm are of minimum width. In contrast, when using the Abbe condenser, the colour fringes can be quite wide and will interfere when taking an image of a neutral colour specimen. In other words, the field diaphragm must be opened to a greater extent on an Abbe condenser than on an achromatic condenser. This can cause increased glare in the image.

Nonetheless, if the microscope comes with an Abbe condenser, its performance can be improved by purchasing a condenser corrected for spherical and chromatic aberration.

The region immediately beneath the stage is the substage. It has the controls for adjusting the illumination system. For example, the condenser is found here. It is supported by a carrier (Fig. 25), which raises and lowers it so that light can be maximally focused on to the specimen. In research-grade microscopes, there are two screws for centring the condenser to the optical axis of the microscope. Within the condenser, there is an iris diaphragm for varying the angle of the cone of light emanating from the top of the con-

Fig. 25 Close-up of the holder for the condenser assembly.

denser. At the bottom of the condenser is a swing-out holder for mounting filters.

Beneath the condenser is the illuminator's field diaphragm, which serves as a focusing reference. When the subject is in focus, the condenser is raised and lowered to superimpose the image of this diaphragm within the field of view. The screws on the condenser carrier are used to centre the field diaphragm's image in the field of view. By opening and closing the field diaphragm, the microscopist ensures that only the area being viewed is illuminated.

Also beneath the condenser is the illuminator, which in modern microscopes is built into the microscope's base. This ensures that the components of the light source are properly positioned: the distance of the bulb and its alignment to the focusing lenses is centred at the factory and does not have to be adjusted. The days of using an external light source and aiming it at the mirror of the microscope are long past.

The light source may be either a tungsten bulb, a quartz halogen bulb, or a light-emitting diode. For work requiring high light intensities, a quartz halogen bulb is used. When run at its specified voltage it provides a colour temperature of 3,200K. If the voltage to the bulb is reduced, the colour temperature decreases and the light takes on a reddish hue. For the photomicrographer, the bulb should be run at its rated voltage. To reduce its intensity, neutral density filters should be used.

One of the best filters for this task are those with Inconel® deposited on to a glass surface. This material contains a number of different elements such as nickel (Ni), chromium (Cr), cobalt (Co) and iron (Fe). The filters are spectrally neutral over a wide series of wavelengths and are superior to absorption filters for maintaining white balance. When purchased new, these filters can be quite expensive. However, Bausch and Lomb made a series of these filters, which can be purchased used on such sites as eBay.

These filters are not rated by per cent transmission or by f-stops of attenuation, but are the log=1/transmission.

Table 1 shows the Bausch and Lomb nomenclature and the per cent transmission of the filter.

The rationale for using a logarithmic scale is that one can quickly calculate how much light will be transmitted when the filters are stacked. For example, stacking two 0.3 filters will give a value of 0.6, which will be a 25 per cent transmission. Essentially every 0.3 unit corresponds to a 50 per cent transmittance. These filters are highly recommended when you need to reduce light intensity. When purchased new, a set of filters can cost £250; in contrast, we bought a set of four filters on eBay for £25.

We do not recommend buying variable neutral den-

| Table 1: The percentage transmission of light in comparison to the markings on a set of Bausch and Lomb neutral density filters ||||||
|---|---|---|---|---|
| Density value inscribed on filter | 0.3 | 0.6 | 0.9 | 1.2 |
| Percentage transmission of light | 50% | 25% | 12.5% | 6.25% |

sity filters. These are two polarizing filters which can be rotated so that their plane of polarization can be either parallel or crossed. When parallel, the highest light transmission is provided, when crossed, the lowest. These filters, especially the inexpensive ones, can impart a blue tint to the light source.

The Head of the Microscope

The microscope head has tubes for holding the eyepieces. For photomicrography, the most convenient design is the one with three tubes, two that hold the eyepieces, while the third is for mounting the camera. With this configuration it is a simple matter to switch between visual observation and taking movies.

The photographic port receives its light via a beam splitter. The inexpensive heads are set up to have the light continuously transmitted to both the eyepieces and the camera. When working under bright light conditions this is fine, but when working under low light conditions this division may make viewing and photography difficult because of a lack of light. A more desirable configuration is one that directs 100 per cent of the light to the oculars or to the camera. This is essential when working under low light conditions.

Older microscopes have a photographic port that is about 25mm in diameter. In contrast, the newer infinity microscopes by Nikon, Olympus, Leica and Zeiss use a much larger diameter photographic port. Generally, these tubes have a C-mount for mounting a dedicated camera. Only rarely is a mirrorless or digital SLR camera used on these types of microscope.

Eyepieces

The eyepiece will have its magnification inscribed on its barrel. Typically this will be 10x; however, visual eyepieces may range from a low of 4x to as high as 25x. For photography, the eyepieces tend to be of lower magnification (0.3x to 2.5x).

These values are multiplied with the magnification inscribed on the objective to determine the total magnification for visual or photographic work. So a 10x eyepiece with a 25x objective will give a total magnification of 250x through the visual eyepieces.

Sometimes microscopes have a magnification changer, which increases the magnification of the objective lens. For example, the Zeiss Universal and Photomicroscope have an Optovar which increases the power of the eyepieces by 1.25x, 1.60x and 2.0x. Using this as an example, if the microscope's magnification changer is set to 1.60x and a 10x eyepiece with a 25x objective is used, the final magnification is 400x. In addition, these magnification changers are useful accessories to the photomicrographer and allow the magnification to be set for a value appropriate to the digital camera being used.

Sometimes the eyepiece will also have the field number (FN) listed on it. This number, when divided by the power of the objective, gives the field of view seen through the microscope and provides a useful idea as to the size of the object being viewed. For those instruments equipped with a magnification changer, the field of view is calculated by dividing the objective's power times the accessory magnification changer power into the FN. That is to say, if the eyepiece's field number is 25, then when used with a 10x objective, the microscopist will see a field 2.5mm in diameter. If the magnification changer is set to 2.0, then you will have, in effect, a 20x objective and the field will be 1.25mm in diameter.

The choice of eyepieces plays an important role in obtaining a quality image. As a general rule, one should use eyepieces and objectives made by the same manufacturer, and with approximately the same date of production. Even though this rule is often broken, it is good to know the reasons for having it.

First, the eyepiece and objective work as a team for correcting chromatic aberration. Apochromatic objective lenses from microscopes with a fixed tube length were designed to work with compensating eyepieces that help correct chromatic aberration. More important is the role of the eyepiece when working with microscopes with differing fixed tube lengths. Leitz instruments are designed to work with

a 170mm mechanical tube length, while most microscopes from other manufacturers have a tube length of 160mm. Fortunately it turns out that the critical tube length is the optical tube length, and in the case of the Leitz and Zeiss microscope it is respectively 152mm and 150mm. Optically this difference is insignificant. If one uses Leitz eyepieces made for the Ortholux on a 170mm tube length microscope, it will handle both the Leitz objectives designed for 170mm mechanical tube length and the other manufacturers' objectives, such as Zeiss, whose objectives are designed for a 160mm mechanical tube length. However, these eyepieces should not be used on a 160mm mechanical tube length microscope.

The issue of mixing and matching different manufacturers' eyepieces becomes more complex when dealing with microscopes having an infinity optics. Part of the compensation for chromatic aberration occurs within an internal tube lens within the microscope. In the case of Nikon, all the optical corrections are made in the objective, while with other manufacturers the tube lens provides additional correction for colour errors.

The infinity optical system has a portion of its optical path where the light rays are travelling in parallel. In this region, the head of the microscope can be raised or lowered relative to the position of the objectives, and one can then interpose a variety of accessories in the increased working area; these might include epifluorescent illuminators with their filters, holders for the analyser, the Bertrand lens, the Wollaston prism and the magnification changer.

Conclusions

A fascinating aspect of owning a microscope is the degree to which it can be customized. This chapter has discussed some of the parts of this instrument in greater detail in the hope that it will help you decide which things need to be upgraded, and which are good enough to remain as they stand.

Although you may be tempted to get the most modern and expensive microscope from a major manufacturer, this strategy limits your versatility because manufacturers made microscopes with infinity tube length, so you are basically locked into one product line and must buy the microscope's components from that manufacturer. And if an accessory is not made by that manufacturer, you would have no recourse but to buy another manufacturer's microscope. It is not possible to interchange objective lenses and eyepieces between manufacturers.

This is in contrast with microscopes designed with a finite tube length. Although the interchangeability of other components may be limited, you can interchange objective lenses and eyepieces between manufacturers. However, the buyer needs to exercise some caution when doing this, as the length of objective lenses varies, with objectives made in the 1980s having a 45mm tube length, while objectives made in the 1950s may be considerably shorter than this (37mm). Mixing and matching these objectives will result in a series of lenses which are not parfocal: that is to say, when one lens is in focus, the other lenses are almost in focus. Also lenses can be damaged by switching objectives on the nosepiece without making sure the front lens does not scrape against the mechanical stage or slide. Some condensers made by different manufacturers can be interchanged if they were sleeve-mounted units without centring screws.

Unfortunately, stages and heads are unique to a manufacturer. Since many of these instruments will appear on the used microscope, this provides an economical means to explore different microscope configurations. In our case, we ended up with three working microscopes to explore different aspects of phase contrast illumination.

CHAPTER THREE

EXPANDING THE SYSTEM

Selecting the type of microscope and its accessories is determined by how you intend to use the instrument. We will discuss several different types of microscope: compound, dissecting, stereo. We will also cover many of the general, and some of the more complex microscope accessories that you might want to use. Several microscope accessories facilitate the task of sample preparation and viewing the specimen; these include glass slides, coverglasses, pipettes and glassware. In addition you may wish to purchase accessory optical instruments to facilitate the task of preparing the specimen for observation with the compound microscope. This chapter will provide an overview of equipment that is desirable for photomicrography.

Fig. 26 Diagram showing the relationship between a glass slide, coverglass and mountant with a specimen.

Slides and Coverglasses

To study a specimen with the compound microscope requires it to be mounted in a matrix surrounding the specimen, and sandwiched between a glass slide and a thin coverglass (Fig. 26). The mountant in these preparations might simply be air, but in the majority of cases it is a liquid, which hardens with time. This may require the evaporation of a volatile solvent, which solidifies the media. Alternatively, the medium may be a solid at room temperature but is liquefied upon heating. An example of this is glycerol jelly, which is liquefied by heating and applied warm to the sample, and then allowed to cool and harden.

For long-term storage, a solid medium is preferred. However, for very fragile specimens, some mountants do not harden and are always liquid. Such preparations have to be sealed to prevent evaporation. For the perfectionist, this may be done with black lacquer, while for many working laboratories it may be nail polish. When viewing pond samples, the mountant is usually water. These are temporary mounts that will be discarded after use.

Glass slides and coverglasses serve to cover the specimen and provide the windows for concentrating light via the condenser, and collecting light by the objective lens. The slide is the substrate upon which the sample rests, and provides a base which is gripped by the stage clips. Coverglasses are the optically defined surface through which light must pass to reach the objective lens. Since they surround the specimen, both must be precision optical elements: their surfaces are optically flat and parallel to each other. The highest image quality can only be obtained if they are of the correct thickness.

If glass slides are much thicker than 1mm, some high numerical aperture condensers may not focus the image of the field diaphragm upon the plane

Table 2: The relation between the numerical rating of coverglass thickness and their actual thickness in mm

Coverglass #	Range of thickness in mm
0	0.08–0.13
1	0.13–0.17
1.5	0.16–0.19
2.0	0.17–0.25

where the specimen rests. If the coverglass is either too thick or too thin, image sharpness and contrast will be reduced. For examining specimens, the objective lenses are corrected for use with a coverglass of 0.17mm thickness. A variation of 0.01mm will reduce image quality by introducing spherical aberration. The degradation in image quality will be apparent by the loss of edge definition in the image, as well as a lack of contrast. This is especially evident when using a dry objective with an NA of 0.85 or greater.

Buying the correct coverglass can be confusing. First, thickness is specified by an arbitrary set of numbers: 0, 1, 1.5 or 2. In addition, this rating is only approximate. The ideal thickness is 0.17mm, but there is no numerical category that contains a predominance of that thickness. In a box of coverglasses rated as being 1.5 the coverglasses will have a range of thicknesses from 0.16mm to 0.19mm. This is not ideal, but it is the best that can be done. In any case, using a 1.5 thickness is better than using a #1 thickness whose range is from 0.13 to 0.17mm, or a #2 which ranges from 0.19 to 0.25 (see Table 2).

The major microscope companies used to sell micrometers for measuring and then selecting coverglasses with the ideal thickness. This is no longer the case, but if you are inclined to do this, digital micrometers can be purchased inexpensively online. However, to benefit from this strategy, the sample must be mounted directly on the coverglass, and for most permanent slides this is not done, as it is more convenient to mount the specimen on the slide. The mountant is applied, and the coverglass gently lowered over it, which spreads the fluid and surrounds the specimen. Invariably some mounting medium will separate the specimen from the coverglass, and when this occurs, critically measuring the coverglass before applying it is futile because the intervening media introduces spherical aberration. It is for this reason that manufacturers make objective lenses equipped with a coverglass correction collar. Adjusting such a collar compensates for variations in coverglass thickness.

It should be noted that most lenses having this feature are dry objectives with a numerical aperture over 0.85. For routine work, dry objective lenses equipped with an NA lower than 0.85 are not sensitive to slight variations in coverglass thickness. It should also be noted that variations in the glass thickness have less effect when using immersion lenses. If the slide is mounted in a material such as Canada balsam, the best lens to use is the oil-immersion objective. Under this condition, the thickness of the coverglass is not important, and indeed this is a situation where using a #0 coverglass is acceptable. A water-immersion lens will also have a correction collar for adjusting variations in the coverglass thickness.

Scientific grade coverglasses are expensive. To save money, you can purchase them through online auction houses, usually at a fraction of the price for new. You can be confident of the good quality of these products if they come from a reputable scientific supply house such as Fisher, SP products, or Van Waters and Rogers. Sometimes such items will need cleaning, and we have found Bon Ami to be a good cleanser.

Monocular Dissecting Microscopes

When working with pond or ocean samples, a low-powered instrument is invaluable for selecting and sorting small organisms such as small crustaceans such as the water flea (*daphnia*) or the freshwater jel-

lyfish (*hydra*). By providing a wide field of view, moderate magnification and a long working distance, these instruments serve as an aid for either dissection or capturing a small organism for mounting on a slide. There is enough magnification to see small organisms that would escape naked eye observation, but it is low enough so you can manipulate fine tools while observing the organisms with the microscope. With the right lighting, you can identify free-swimming protozoa such as *paramecium* (250 microns in length), and the magnification is low enough that you can position the mouth of a pipette to capture such small organisms. These instruments can be very inexpensive, costing as little as £65 new, and are useful for introducing students to the wonders of pond and ocean life. Once the student decides to use more advanced instruments, these instruments will be useful for taking out in the field and scanning the sample for live animals.

Binocular Stereo Microscope and Illuminator

The sorting and selection of specimens is more conveniently done with more complicated instruments called stereo microscopes. These have the advantage of giving a three-dimensional view, and their design is equivalent to having two microscopes mounted side by side. This makes for more complex optical design, and as a consequence these instruments will be significantly more expensive than a monocular microscope with a single eyepiece and objective. However, their cost is offset by the advantage of the ease with which the subject can be studied and manipulated. These instruments can cost anywhere from £150–£10,000, and as such they cannot be regarded as a minor acquisition.

There is an overlap in the magnification that can be covered between the stereo and the typical compound microscope, described in chapters 1 and 2. Both instruments can be equipped with a low power objective lens ranging from 1.0x to 2.0x, and so both instruments can present a final magnification range between 10x and 20x. Deciding which instrument to use for photography will depend on the specimen.

The 1 and 2x objectives on the compound microscope have a short working distance. Generally, there is only 1 to 2mm separation between the lens and the top of the specimen. Consequently, such objectives are best used on thin slices of tissue mounted on glass slides and viewed by transmitted light – that is to say, light that arises below the specimen and is transmitted through it to the objective lens. The long working distance objectives of the stereo microscope (75 to 100mm) can view unmounted specimens. A small insect or a petri dish with a water sample can be viewed with this type of microscope. This is convenient for viewing a specimen by reflected light since you can angle the direction of light so it will be reflected from the specimen into the objective lens. Such conditions preclude using a compound microscope's 1 or 2x objective lens. Its short working distance will block the light from an external light, and it will be impossible to angle the light so it can reflect off the specimen and into the objective lens.

If, however, you need to photograph a stained tissue section mounted on a glass slide (Fig. 27), the compound microscope is superior. Under this condition, the sample is illuminated with transmitted light from the condenser and the objective's short working distance is not a handicap. You will find that under these conditions you have greater control of the lighting. With most microscopes, you will have to remove the condenser's top lens and instead use its bottom lens.

The disadvantage with this simple solution is that there is light fall-off at the periphery of the field. If you want to obtain true Köhler illumination with an even field of illumination, you must buy a special low power condenser. Such a condenser is designed to be used solely with objectives whose magnification is less than 4x. It will focus the illuminator's field diaphragm on to the plane of the specimen. In addition, the internal iris diaphragm of this condenser can be adjusted to match the numerical aperture of the objective lens. Such a condenser provides even illumination for an area 22mm in diameter.

Fig. 27 A condenser with a 'flip' top element. The one on the left is used with the top element in place for high power work, while the one on the right is used with the top element swivelled out of the light path for low power work.

Stereo microscopes can image an even greater area. The most basic stereo microscopes are mounted on a stand with a rack-and-pinion focuser. At this level, the specimen is illuminated by reflected light. The sample is placed on a removable flat plate, one side of which is painted white and the other black. The plate is used with an external light source, and if this light casts shadows surrounding a small specimen, the dark shadows can be lightened by using the white side of the plate. If you want dark shadows, then the black side of the plate is used. This design is limiting for photographic applications, and if your budget allows, you should buy a more elaborate base containing a built-in illuminator. This will allow you to illuminate transparent specimens with transmitted light, and this is advantageous for aquatic organisms that are often translucent. Passing light through them can help reveal their internal structures.

Depending on the design of these built-in illuminators, you can angle the light so as to achieve oblique or darkfield illumination. In the former case, light is slanted so it goes through the specimen at an angle before it enters the objective lens. This creates a 'shadow' effect at borders, with one side being bright and its opposite side dark. If the light is aimed at an even greater angle only the specimen is lit, and the direct light from the light source misses the objective. The specimen scatters the light, which is captured by the objective lens. Since the direct light from the light source does not enter the objective lens, you obtain the effect of the subject glowing against a dark field. Varying the lighting angle can enhance the specimen's appearance thereby making its study easier.

A useful accessory for this type of microscope is a fibre-optic illuminator. These are used to illuminate the specimen so it can be observed with reflected light. The tubes can be adjusted and aimed at the specimen. If you get an illuminator with two optic guides, you can illuminate the specimen from left to right. With this set-up you have control as to how dark the shadows will appear on a rough object. If you want shadowless lighting, aim two fibre-optic illuminators at the sample, one on the left side and the other directly opposite, with both positioned equidistant to the subject. If you want to provide shadows, one fibre-optic is displaced further from the subject. The degree of darkness of the shadow can be controlled by how far the fibre-optic is distanced from the sample.

Upgrading and Choosing Objective Lenses

We use 1.25 and 2.0x objectives for low power photomicrography of stained slides. These objectives are not included with most compound microscopes. We found we could get better results with these lenses than when we used a stereo microscope. Similarly, as you continue to work with your microscope, most likely you will find you require the addition of objective lenses to complete a specific project.

Selecting an objective lens requires an understanding of the constraints imposed by the sample, and how it is mounted. This was the case when using low power objectives on our microscope. On occasion, you may sacrifice a lens's resolving power to gain increased working distance when the specimen is mounted under too thick a coverglass. For example, if you are working with deep culture dishes or compressors, a long working distance may be required and resolution may be sacrificed. For example, depending on the specimen, we choose between one of four 40x objective lenses to use for for our work. Normally, we use the 40x NA 0.65 objective for most of our work. This lens is versatile and convenient to use. It has enough working distance so it can be used on a variety of specimens. Even if the mount is overly thick or the coverglass is too thick, this lens will generate a usable image. However, you may wish to have greater resolution than is provided by this lens, and there are several options with regard to selecting an alternative lens.

To attain this, you must replace it with one with a larger NA. If you elect to use a dry lens, it will have a shorter working distance and you may not achieve focus when you attempt to view a sample having an overly thick coverglass. When working with living specimens, this can be a problem when you have too much water and the specimen is not close to the undersurface of the coverglass. However, a dry lens has the convenience of being usable without having to add oil to the coverglass. With it, you can switch

Table 3: A comparison between Olympus objectives' NA and working distance.

Correction collar	NA	Description	Working distance in mm
Yes, for inverted stand working with tissue culture plates	0.60	40x dry, achromat	4.2
No	0.65	40x dry, achromat	0.60
Yes	0.85	40x dry, apochromat	0.13
Yes	1.0	40x oil immersion, apochromat	0.12
Yes	1.15	40x water immersion, apochromat	0.25
No	1.0	50x oil immersion, apochromat	0.20

back to a lower power objective if you need to rescan the slide. To give the best quality image, this objective should have a correction collar to correct for spherical aberration if the coverglass is too thick or thin.

If you want higher resolution, you need to use an immersion lens. An oil-immersion lens is excellent for high resolution studies on permanent slides. When used in this fashion it does not need a correction collar for optimum performance (assuming the mountant's optical properties are the same as glass). The disadvantage in using this lens is its inconvenience. The slide and lens will have to be cleaned, and removing the oil takes some time and effort. If you are viewing a live sample, you cannot go back to a lower power dry lens.

A good compromise is to use a water-immersion 40x objective. Distilled water is placed between the objective's front element and the coverglass. Water can be removed easily from the slide, and cleaning it up is a simple matter. This type of lens is most frequently used with live samples in an aqueous environment. As a rule of thumb, an oil- or water-immersion lens will have more working distance than a dry lens with an NA of 0.95. However, there are exceptions to this rule, and studying the technical specifications of the lens is fruitful. Table 3 provides an example of the variation of objectives having a magnification of about 40x.

In summary, a microscopist has a broad selection of objective lenses, and NA is only one criterion for selecting the best lens for the job. As you explore more and different samples, you will seek to supplement or replace the objective lenses on a microscope. If you peruse the manufacturers' catalogues you will find that for an objective of a given magnification, there will be several models.

We have discussed NA earlier, and we will discuss it in greater detail here. Theoretically, NA defines the resolution that the objective lens can obtain under ideal conditions. It is described by the following equation:

$$MRD = \frac{0.61\lambda}{NA}$$

MRD stands for the 'minimum resolved distance', the smallest distance between two objects that are distinguished as being independent and separate. Lambda is defined as the wavelength of light used to illuminate the sample, and its value is described in nanometers (nm).

You will note that this equation does not have any symbol for magnification. Magnification by itself cannot resolve fine structure. Indeed, with a selection of eyepieces, magnification changers and objectives you can achieve a magnification of 4000x, but for most people with normal eyesight this does not reveal any finer details than if you were to use a magnification of 1400x with an objective having an NA of 1.40.

However, NA can be used as an empirical tool to calculate the limits of useful magnification. In the example from the previous paragraph, any magnification greater than 1000x NA yields what is described as 'empty magnification'. For most users there is little advantage in using an objective with an NA of 1.40 at a magnification greater than 1400x, as doing so does not reveal any finer detail. Correspondingly, there is the concept of useful magnification. Table 4 lists the limits of useful magnification. This is a pragmatic guideline based on people with normal eyesight.

Applying this rule to a 40x objective with an NA of 0.65, you can use a 15x eyepiece to effectively work at 600x. This is within the range of useful magnification, and will enable the average-sighted person to see all the fine detail resolved by the objective. If, however, the user substitutes a 20x eyepiece to view the specimen at 800x, this is empty magnification and it will not reveal any finer detail than what can be seen at 600x.

Chapter 1 described the basic microscope controls, how to set up Köhler illumination, and how to use an oil-immersion objective, and these basic skills will be all that many people need to photograph specimens successfully. But selecting the lens for a specific task requires an intuitive grasp of optical theory, and it must be remembered that images viewed through a microscope are the result of complex interactions of light: what we see is a representation of the real structure that changes as the lighting is altered. Chapter 2 provided a more detailed view of the microscope

EXPANDING THE SYSTEM

Table 4: The NA of standard achromatic objectives is well adapted to being used with a 10x eyepiece.

Objective mag	NA	1000x NA	Final mag with 10x eyepiece	Eyepiece needed to reach empty mag
4 achromat	0.10	100	40	25
4 apochromat	0.16	160	40	40
10 achromat	0.25	250	100	25
10 apochromat	0.45	450	100	45
20 achromat	0.45	450	200	25
20 apochromat	0.75	750	200	37.5
40 achromat	0.65	650	400	16.5
40 apochromat	1.0	1000	400	25
60 achromat	0.95	950	600	16
60 apochromat	1.40	1400	600	23
100 achromat	1.25	1250	1000	12.5
100 apochromat	1.40	1400	1000	12

parts; this section will take it further and provide information for upgrading the parts.

Working at higher magnification reveals the subtle effects that optics have on light. At lower powers these effects are minimal and do not detract from image sharpness, but when working at powers of 100x and higher, their effects are sufficient to reduce image sharpness. For example, a lens acts like a prism and separates white light into different wavelengths (that is, colour) measured in nanometers (nm). Blue light (a shorter wavelength, 490nm) comes into focus closer to the lens than red light (a longer wavelength, 600nm). As a result, a high contrast border will display a colour fringe (Fig. 28), called 'longitudinal chro-

Fig. 28 A resolution test target imaged with a lens not corrected for chromatic aberration. Note the colour fringes at the edges of the border.

matic aberration'. There is also the phenomenon of lateral chromatic aberration, which results when the two different colours are magnified to a different extent. In either case, chromatic aberration blurs the border of the subject when it is illuminated with white light.

Colour fringes can be corrected by using multiple glass elements to form a compound lens. By focusing two wavelengths of light, usually red and blue, a compound lens shows reduced colour fringing. This type of lens is an achromat, meaning 'without colour'. Achromatic objectives are the basic lenses used by the microscopist. They are economical; however, in spite of their name they still exhibit colour errors. Although the lenses can bring two extreme wavelengths, blue and red, to a common focus, there are still colours with wavelengths longer than 490nm and shorter than 600nm that are not brought to the same focus. This situation is described as 'residual chromatic aberration'.

To provide improved colour rendition, glass with unusual optical properties is used to make the objective. These objectives focus at least three different wavelengths to the same focal point: blue, 490nm; green, 550nm; and red, 600nm. Such a lens is described as being apochromatic. The extra correction capabilities make these lenses more expensive. Frequently, fluorite is used to make these lenses. A compromise lens is one described as semi-apochromats (or fluorites): these have an intermediate degree of optical correction.

The initial definitions for these terms were made in the 1950s, but they have changed as lens designs have improved. Today's achromatic lens can focus three colours to a common point, while an apochromatic lens can focus four or more colours to a common point.

Another term a microscopist should know is 'spherical aberration'. This is the failure of the lens to bring all the parallel rays of light to a focal point, because rays that strike the peripheral edge of the lens are brought to a different focus than rays that strike the centre. Images viewed through a lens with spherical aberration appear soft, lacking definition and contrast: edges are not well defined, and image contrast is reduced. Using multiple lens elements and aspherically ground surfaces can solve this problem.

Spherical aberration occurs when using incorrect coverglass thickness: that is to say, one whose thickness is not 0.17mm. Fig. 29 shows the appearance of a section when the correction collar is set incorrectly, while the right side of Fig. 30 shows the quality of the image when this control is set correctly. With a slide whose mounting material has the optical properties of glass, such as Canada balsam, this problem can be avoided by using an oil-immersion lens.

Fig. 29 This photographs shows the results of setting the correction collar incorrectly.

Fig. 30 This photograph shows the results of setting the correction collar correctly.

Oil-Immersion Objectives

As mentioned in Chapter 2, a light ray emanating from a specimen mounted under a coverglass takes a different path if the front element of an objective is in air as opposed to being immersed in oil. As the ray emerges from the coverglass into the air, the air's lower refractive index causes it to bend outwards. As the angle increases, the ray is reflected out of range of the objective lens instead of going up into it, and in some cases the ray is reflected back downwards through the coverglass and slide. In contrast, a light ray emerging from the coverglass into oil does not deviate at all because oil's refractive index is the same as glass (1.515), allowing the light ray to continue travelling in a straight line through the coverglass and into the objective lens.

By working in a medium with a higher refractive index, more light rays travel upwards towards the objective. If the objective fails to capture these rays, its resolution is reduced. The oil used to connect the immersion objective to the coverglass ensures that even the most angled light rays are captured, rather than being reflected down and away from the objective.

The Objective Lens: Types and Controls

As we have stated earlier, objective lenses are characterized as being either dry or immersion: the former has a front element that works in air, while the latter has a front element that works in a liquid. Most commonly, the immersion liquid is oil with a defined refractive index (n) of 1.515. There are other immersion objective lenses designed to work in water rather than oil. A water immersion lens may be a simple dipping lens where the specimen is in a petri dish and the lens is lowered directly into the medium, or where the lens is attached to the specimen's coverglass with a drop of water. Immersion objective lenses can have a numerical aperture greater than 1, giving them the highest capabilities in discerning fine detail.

Dry objective lenses are sometimes described as 'high dry' or 'low dry', depending on their magnification. High dry lenses have a magnification greater than 20x, while low dry lenses have a magnification less than that. In all cases, dry lenses have an NA of less than 1: the highest NA is 0.95. For light of a wavelength of 550nm, these lenses should be able to resolve objects separated by 0.35 microns.

Non-immersion and water-immersion objectives with a high NA (greater than 0.8) have a rotating collar on the barrel of the lens to correct for variations in coverglass thickness. Such lenses assume that a thin optical element – a coverglass – with a refractive index (RI) of 1.515 and a thickness of 0.17mm lies immediately over the specimen. If the coverglass is of a different thickness, the objective lens correction for spherical aberration is reduced, and the resulting image has low contrast, as though a film were spread over the surface of the lens. Fine details that should be visible are obscured.

To correct this image degradation, the objective's collar rotates and compensates for incorrect coverglass thickness. It takes some skill to apply this correction by rotating the collar, because as you turn it, the image is thrown out of focus. To determine whether the adjustment has improved the image, you must refocus the specimen. Judging the quality of the improvement requires mentally comparing the 'before' and 'after' images. It should be noted that an oil-immersion lens does not require any adjustment for variation in coverglass thickness if the sample is mounted in Permount or another medium that has the refractive index of glass.

Water-Immersion Lenses versus Oil-Immersion Lenses

Water-immersion objective lenses have had a resurgence in popularity due to the interest in live cell imaging. This research endeavour was not so widespread in the 1960s, and the availability of this type of lens was limited. Consequently for those who have finite tube length microscopes there is a dearth of these lenses on the used market. This is not the case for modern infinity tube microscopes made by Olympus, Leica, Nikon and Zeiss. A modern research laboratory interested in doing live cell studies will buy the latest model microscope with water-immersion lenses. In the clinical field where workers study stained permanent slides, there is little need for these lenses and instead they will use an oil-immersion optic.

Water-immersion lenses have two limitations. First, their maximum NA is limited to 1.2, so they cannot match the resolution capabilities of an oil-immersion lens of 1.4. Second, they require skill to get the most out of them. Invariably they are equipped with a correction collar to compensate for variations in coverglass thickness.

The popularity of oil-immersion lenses with permanent slides can be attributed to the ease with which they can be used. An untrained worker will not need to 'tweak' the objective lens for the best image quality. That said, water-immersion lenses do have their advantages. Personally, since most of our work is with aqueous samples, we enjoy working with these objectives since, unlike oil objectives, it is easy to remove the water and return to a lower magnification.

Objective Lens and Design

About twenty years ago the design of the microscope changed radically. Prior to this time, the manufacturers Zeiss, Leitz, Nikon and Olympus used a fixed tube length or finite optical system. However, this was abandoned in favour of an infinity optical tube length design, because with this system manufacturers could design accessories that could be easily inserted between the objective lens and the eyepiece, such as magnification changers, epifluorescent filters and illumination devices. Thus, a basic microscope stand can be customized to the buyer's specifications. It also forced many laboratories to purchase new microscopes if their laboratory directors wished to ensure their researchers were using the latest in optical design.

A consequence of this development was the obsolescence, for the research biologist, of fixed tube length microscopes. This proved to be a blessing to the avocational microscopist, as many research-grade instruments became available at affordable prices; thus many avid photographers came into possession of phase contrast, DIC and epifluorescent microscopes. However, these older designs are limiting in that the development and refinement of optics cannot be applied to them. The development of such things as apodized phase contrast objectives is restricted to their infinity tube length microscopes. For the other companies, new water-immersion lenses, silicon-immersion lenses, are also restricted to their newer microscopes. Some of the new infinity tube length microscopes have appeared on the used market; however, their price is significantly higher than the older finite tube length microscopes.

You have to be cautious when purchasing older lenses. Zeiss apochromatic objectives have a reputation for delaminating, and you need to inspect them carefully before purchase. Depending on the storage conditions, any manufacturer's objective can suffer from this defect. In addition, because of bad storage conditions, fungus can grow on the lens surface. In either case, if the defect is limited to a small area, the performance of the lens may not be impacted seriously. There is a tool called the phase telescope which is useful to own, even if you don't have a phase contrast lens. This telescope will replace an eyepiece, and will provide a magnified view of the back of the objective lens. We use this frequently to evaluate used objective lenses.

Also, the older microscopes have a narrower usable field of view than most of the newer infinity microscopes. In particular, objectives that are not classified as being flat field, will not lend themselves to wide field work. Visually they are quite usable, as an experienced microscopist tends to vary the fine focus to view both the centre and periphery of the field. However, cameras are not so flexible, and the curvature of the field becomes very evident.

Upgrading the Condenser

Proper illumination of the microscope requires that the condenser concentrates the illuminant's light on the specimen. The first task is to establish the optical plane of the specimen by viewing it through the eyepiece and adjusting the stage so the specimen appears sharp. Now, you are focused on the specimen plane. Next, by raising and lowering the condenser, you can see the light source and focus its image on to the specimen plane. When the image of the illuminant is superimposed on the specimen, its light is maximally concentrated on the subject.

In the 1800s, an oil lamp's flame served as the indoor light source. The lamp was placed in front of the microscope, and a substage mirror was tilted to direct the light towards the bottom of the condenser. Since a broad flame generates a wide image, the subject was evenly illuminated when the flame's light was projected on to the specimen plane. However, this situation changed when electrical light sources became available. A light bulb has a coiled metallic filament for generating light. Compared to the size of a flame, this light source is much smaller, so when the condenser focused its image on to the specimen plane, the field was not uniformly illuminated; instead, the brightly glowing filaments were seen as superimposed on the specimen. This distraction interfered with studying

the specimen's fine details.

To enlarge the physical size of an electrical light source, a ribbon lament bulb was used. This was a 2x 18mm rectangular filament that was focused on to the specimen. Edward Nelson was a proponent of this type of lighting, and it was previously known as 'Nelson critical illumination'. Today it is known as source-focused illumination.

Using a modified form of lighting is simple and inexpensive. All you need is a frosted light bulb and a microscope with a mirror for directing the light to the condenser. Place the frosted light bulb in front of a microscope, and aim the mirror so that light is directed up towards the condenser. Then take a slide and focus on it using a low power objective lens. When you have a sharp image of the subject, raise and lower the condenser focusing controls until the image of the light source is focused on the specimen. Usually slight imperfections on the bulb's surface can be used for focusing it on to the specimen plane. This form of lighting is suitable for teaching microscopes; microscopes to be used for photomicrography should be equipped with a built-in illuminator for achieving Köhler illumination. This provides an even field of illumination, and it is employed in some form by all microscope manufacturers on virtually all their microscopes.

Condensers come in a variety of configurations. Those used in a 'dry' configuration, with their top elements working in air, limit the NA to slightly less than 1. Just like objective lenses, condensers designed to work with oil immersion are marked with an NA greater than 1 (NA 1.2 to 1.4). To get a larger numerical aperture for the highest resolution work, you need a condenser designed to work in oil. Such a condenser requires oil contact between the top element and the bottom of the slide. Working with a condenser and an objective lens oiled top and bottom to the slide provides the highest resolution image; however, such work is messy.

Many microscope users decide that cleaning the lens is too inconvenient for routine work, and use the condenser dry. For most transmitted light work, oiling the condenser is unnecessary; with stained slides, the loss in performance is so slight that for routine work it is not noticed. It is only noticed for those who work at the microscope's limit of resolution. For example, in video microscope studies of subcellular organelles and microtubules, resolution is improved when the condenser is oiled to the slide. These were studies that used differential interference contrast, and the authors amplified the specimen's contrast electronically. In this case, the condenser was used oiled, and its iris diaphragm was fully opened.

Frequently, an expert microscopist will seek to upgrade his microscope's condenser. The typical condenser provided by the manufacturer is a low cost Abbe condenser – though these are not corrected for spherical or chromatic aberration. If you are interested primarily in brightfield work, your images will have a higher contrast and resolution with a condenser corrected for these two aberrations. In addition, it is advantageous to have a condenser whose top element can be removed, so it can be used with lower power objectives than 10x.

Conclusions

Using a compound microscope is facilitated by having the right accessories for the job. Although it seems exorbitant to purchase a low power microscope in addition to the compound microscope, it is a worthwhile expenditure, especially for those working with animals harvested at the beach or from a pond. The low power instruments are invaluable for selecting and sorting the samples prior to viewing them at higher power with the compound microscope. Having this lower power capability is advantageous for some of the denizens of the pond. For example, *hydra*, small crustaceans and *byrozoa* are especially stunning when viewed at 20x. If you use a stereo microscope, the three-dimensional view obtained with these microscopes is striking. Although you can study the *hydra* capturing a small crustacean with a compound microscope, this activity is best appreciated with a low power scope.

Coverglasses and slides are supplies that you will need to purchase and replenish as they are essential

for viewing the sample. Although 1 x 3in slides are the most common, when working with temporary mounts of live organisms the larger 2 x 3in slides can be most convenient. When used with oversize rectangular coverglasses of 24 x 60mm, they can provide a large area for studying small animals. Do not make the mistake of just lowering the coverglass on to the specimen, because for animals such as *paramecia* (250 microns in length) the weight of the coverglass can crush and damage these organisms. A small riser made with quick-drying nail polish can help with prolonged observation of these organisms.

Most laboratory microscopes come with 4x, 10x, 40x and 100x objectives, but you will undoubtedly wish to supplement these with objective lenses of your own choosing. We usually purchase a 20x objective to provide an intermediate increase in magnification between the 10x and the 40x objective. One of our personal favourite lenses is a 25x objective with an NA of 0.70. This lens is one of our most used objectives for photomicrography. When selecting additional objectives, there are three things to be considered: its numerical aperture, its working distance, and the medium in which it is to be used.

NA reflects the putative resolving power of an objective; however, this does not guarantee that its visual or photographic performance will be good. Obviously, a lens can be damaged so it will not reach its full resolving power. However, there may be design constraints within the lens which limit its optical performance. A case in point is that Olympus used to manufacture a 40x UFPL NA 1.30 apochromatic objective for fluorescence microscopy. This was a superb lens for fluorescence microscopy: it generated images that were sharp and bright with no flare. However, when compared to Olympus' SPlan apochromat, its brightfield view lacked the SPlan's image quality. The contrast was comparable; however, edge definition was less. This difference was evident when doing a side-by-side comparison between the two objectives. Although obvious by direct comparison, this deficiency was not noticed when the lens was used by itself. This experience illustrates two points. First, numerical aperture is not the sole criterion by which a lens should be evaluated. Second, the difference in performance in lenses requires a direct comparison between objectives. One needs to evaluate the performance of a lens by comparing it with an objective of known quality.

NA's benefit of higher resolution may come at the cost of convenient operation. If a dry lens is used, you will need to adjust its correction collar for the optimum image. If an immersion lens is used, you will need to apply the appropriate medium between lens and objective. To make the best selection of an objective lens, you need to envision how it is to be used.

CHAPTER FOUR

INTRODUCTION TO CAMERAS

Several decades ago, photographers used film. Depending on the subject, the decision was to select which photographic emulsion would be the most appropriate for the task at hand. Photographers regarded the camera body as a simple box for holding film and mounting a lens: for obtaining the best results, selecting the camera body was less important than selecting the type of film.

This is no longer the case. To get the best possible results, a digital photographer needs a multitude of cameras, each equipped with a specialized sensor best suited for the task at hand. Ideally, the photographer will have a camera for recording colour and another for working with black-and-white (monochrome). However, this can get very expensive, and most laboratories and individuals cannot afford to adopt such a strategy. The practical solution is to select a versatile camera that can undertake several tasks. For example, a camera that records colour can still be used for black-and-white photography. This is accomplished by stripping away the colour information with image-processing software. However, although the resultant images appear satisfactory, in comparison to a black-and-white camera, they will have less detail and more noise.

This strategy cannot be followed all the time as there are conditions where you cannot compromise on image quality. This is especially noticed when the highest data integrity and the highest light sensitivity are needed. Under these conditions, a high pixel count colour camera is unsuited for low light work, and instead, a smaller pixel count monochrome camera is a more suitable tool.

The most versatile general-purpose tools available to the photomicrographer are the interchangeable lens cameras, the digital SLR and the mirrorless camera. Not only can they be fitted with wide angle, telephoto or macro lenses for general photography, but they can be mounted on the microscope. Further, their sensors can be modified so they will have enhanced sensitivity in the infrared or the ultraviolet. Such cameras can cost anywhere from £200 to £1,500. Unfortunately they are unsuitable for some tasks; for example, they lack the sensitivity for recording dim fluorescent subjects, and for this a dedicated photomicrography camera is the better tool.

A dedicated photomicrography camera is tethered to a computer, which serves as its operational centre. The keyboard inputs commands to the camera, and its monitor serves as the camera's viewfinder. Finally, the hard drive stores the picture and movie files. Such a camera can be purchased in many configurations: it can be either colour or black-and-white; its sensor may be designed to record UV, infrared or visible light; and for very low light work, it may be equipped with the Peltier cooler to reduce the temperature of the sensor.

You might wonder if other cameras can be used for photomicrography, and the answer is a conditional yes. You can position a camera with a lens over the eyepiece, and if its lens is properly orientated (and has the right design), the camera can capture an image from the microscope. This is described as afocal photography.

Afocal Photography: Cell-Phone Cameras

Because of the variety of cameras, it is impossible to

write a concise and brief description on how to mount a current, non-interchangeable lens camera over the microscope eyepiece, because the design of the cameras and their lenses varies. Since cameras can come with either a fixed focal length lens or a zoom lens spanning 9mm to 146mm, it is impossible to make and design a universal microscope adapter. This was not the case several years ago when the Nikon Coolpix 950 camera was available. Serendipitously, the threads of its lens would engage the threads found on the Leitz Periplan eyepiece. By screwing the two together, the camera and eyepiece were perfectly aligned and became a unit to replace a visual ocular; together, these two components made a very usable photomicrography camera.

This was a boon when digital cameras were prohibitively expensive, but unfortunately the Nikon Coolpix 950 camera is discontinued, as is the Leitz Periplan eyepiece (at least, the design for the 170mm tube length). Although both can be purchased used from online auction houses, the advantage for doing this is questionable. For one thing, the camera may not be repairable if it breaks. Second, the eyepiece was made to perform best with a microscope with a 170mm tube length, and it will not perform well if used on a modern microscope designed for an infinity optical tube length or a 160mm tube length.

Today there is one camera that can be adapted easily for afocal photography: it is the one found in cell phones. One of the most engaging activities is showing youngsters new objects under the microscope, and if you do so, some will use their cell-phone cameras to record their new observations and share them with their friends. The lenses in these cameras are small and can easily be held over the microscope's eyepiece. With patience and perseverance an image from the microscope's ocular is seen on the phone's display screen. Once this is accomplished, a photograph can be taken.

It takes patience to handhold the cell-phone camera and align its lens to the eyepiece. The camera lens must be centred to the eyepiece, and it must also be aligned to its optical axis. In other words, the lens cannot be tilted relative to the eyepiece. While this can be done empirically, the task is facilitated by using a mechanical aid to line up the cell phone's camera lens to the eyepiece (Fig. 31). We used the MiPlatform, and have learned some helpful strategies in getting the most out of cell-phone cameras.

Fig. 31 The MiPlatform mounted on a microscope's eyepiece tube. It provides a base for supporting the camera.

First, the cell-phone support should allow for being raised or lowered over the eyepiece. By adjusting its height, the widest field of view can be recorded from the microscope. Second, these phones benefit from using wide field eyepieces. Finally, the adapter should have a means of holding the cell phone so it will not drift out of position. Using the cell-phone camera in this fashion is convenient and can be invaluable for outreach programs seeking to instruct students on microscopy. We use this adapter with our cell phone to take photographs from microscopes that lack a phototube.

As you gain experience, you might want to upgrade the software for operating the camera phone. In the case of the iPhone 6, we added the app Camera+. This software gives us greater control over white balance and exposure. You should select an app that lets you override the camera's automatic settings and allows you to set the shutter speed, white balance and gain. An equivalent program for those who use Android-based phones is 'Manual Camera'.

Fig. 32 A photograph taken with an iPhone held over a microscope's eyepiece. The photograph on the left was taken with a standard field eyepiece, and the one on the right with a wide field eyepiece.

We found that touching the phone's screen to fire the camera caused movement, which blurred the photograph, and were pleased to discover that attaching the iPhone's accessory ear buds provides a remote release. When the volume control on the ear buds' cable is pressed, the camera fires.

A feature of pictures taken with the cell phone's camera is their circular border (Fig. 32). This is due to the short focal length of its camera lens. It provides a wide angle view which accepts a greater angle of view than the one generated by the microscope eyepiece. This is unavoidable, and you will have to digitally enlarge and crop the image to have a picture in a rectangular frame. To maximize the coverage of the subject, wide-angle eyepieces should be used. The left side of Fig. 32 was taken with an iPhone using a standard field 10x eyepiece. The image on the right side was captured with the wide field 10x eyepiece of a Leitz Orthoplan.

Cameras and Vibration

There are two general classes of interchangeable lens camera: the digital SLR and the mirrorless camera. The digital SLR is characterized by directing light between an optical viewfinder and a sensor. This is a sequential process performed with the aid of a hinged mirror. Light from the lens is reflected by the mirror to the top of the camera, which has an opalescent screen. The photographer sees what the lens sees by viewing the screen. When it is time to take the picture, the mirror is swung out of the way to allow light to proceed to the back of the camera. Exposure is initiated when an opaque curtain slides out of the light path, and is terminated by a second curtain that slides in and covers the sensor. At this point the mirror swings down and directs light back to the opalescent screen.

A mirrorless camera lacks both a mirror and an opalescent screen. This type of camera uses the signal from the sensor to drive an electronic viewfinder. When the picture is taken, the signal is diverted and its data saved to a memory card. The distinction between digital SLR and mirrorless cameras is blurred when the camera is used to take high definition (HD) videos. Since the digital SLR mirror is locked up and its rear display screen serves as a monitor, the camera is operationally mirrorless.

The Sony SLT camera series is a hybrid design. It has a semi-transparent mirror that splits one third of the light to its autofocus sensors and the remainder to its imaging sensor. Operationally, this is a mirrorless camera since there is no optical viewfinder and the sensor drives an electronic viewfinder. For the photomicrographer, the design has the advantage of removing the swivelling mirror. Like the mirrorless camera, this design eliminates mirror slap, which shakes the camera and blurs the image. Its disadvantage is the reduced intensity of light projected to the sensor.

In all these cameras, the shutter controls the duration that light falls on the sensor during exposure. When a picture is being recorded, the camera's first shutter curtain shields the sensor from light and initiates exposure by moving to one side. Then to terminate exposure, the second shutter curtain slides into place, covering the sensor from light.

Traditionally, these two curtains were physical implements that moved in front of the sensor. Today, this function can be done electronically so that the shutter has no moving parts, or the design can be a combination of electronic and mechanical devices.

Depending on the shutter design, the camera will

exhibit different degrees of vibration during exposure. In some cameras both the first and second shutter curtains are electronic and there is no tremor throughout the recording of the picture. In other cameras, the first curtain is electronic but the second curtain is mechanical. This results in a vibration-free initiation of exposure, followed by a period of oscillation. The recorded picture is sharp because the camera vibration does not appear until after the picture is taken. However, if the camera is fired immediately after the initial exposure the second image can be blurred, as this subsequent exposure may experience camera movement arising from the previous shot. Finally, in some cameras both curtains are mechanical and vibration will occur at the onset, during, and following the termination of exposure.

For mirrorless cameras, the disadvantages of using the all-electronic shutter are that it may not allow exposures longer than a second, it cannot be used with a flash, and it may reduce the dynamic range of the sensor.

Table 5 summarizes the types of shutter and their effects on exposure. The all-electronic, shutter-type camera is desirable as it can be used to fire repetitively in rapid succession without any fear of vibration.

The all-electronic shutter curtain is rare for mirrorless or digital SLR cameras. It is a feature on the newest camera models. What is more common is a hybrid shutter, where the first curtain is an electronic device, but the second curtain for terminating the exposure is a mechanical implement (as mentioned above). This feature is known as an EFCS ('electronic first curtain shutter'). With this design, the initiation of the exposure is vibration free, but its termination creates vibration. Fortunately, the oscillation occurs after the image has been recorded so that the picture is not blurred. If, however, you shoot in a burst mode or continuous firing mode, vibration can blur the subsequent exposures. That is to say, if you take three or more images per second, jarring resulting from the first exposure will blur the subsequent photographs.

It should be noted that EFCS is also a new development and is not found on all recently manufactured mirrorless or digital SLR cameras. Examples of cameras having this functionality are the Sony a77, a77 II, a99, a7s, a7s II a7, a7 II, and a7R II. Sony has enthusiastically adopted this technology and only a few of their current cameras lack this feature. For example, the Sony a7R does not, but this was remedied when the camera was replaced with the a7R II. Sometimes this feature is described as providing a 'silent' or 'quiet' operation when taking candid photographs. Many Canon digital SLRs have this feature, while, to our knowledge, only the Nikon D810 has the EFCS feature. In addition, EFCS is not common in those cameras using the Four Thirds size sensor. The majority of Olympus and Panasonic GH series cameras lack this feature. In the case of the Panasonic GH4, one can activate an all-electronic shutter which allows for vibration-free pictures.

Table 5: The general class of shutters found on photomicrography cameras

Shutter Type	Potential Subjects	Vibration
Mechanical shutter	Stationary subject	During and after exposure
Electronic first curtain	Live/stationary subjects, single exposure	None during exposure, some after exposure
All electronic	Live/stationary subjects, single, burst shooting modes	No vibration

The most limiting situation is to have an all-mechanical shutter, as frequently there will be shutter speeds that generate severe enough vibration to blur the image. There are, however, a couple of strategies that can be employed to eliminate the blurring effects of vibration. The first is to use a long exposure of one second or longer. Generally, vibration initiated by the mechanical shutter persists for a fraction of a second, and then dies down. If the image is recorded while the camera is oscillating, it will be blurred by movement. However, if you use a shutter speed of over one second, the vibration dies out and the majority of the exposure is made while the camera is steady. If this stationary period makes up the bulk of the exposure, the recorded image will be sharp. The limitation is that it can only be used with stationary objects.

We achieve these long shutter speeds by reducing the light. When we find an area we wish to photograph, we will add neutral density filters to attenuate the light intensity. Since the filters can be stacked for a cumulative darkening of the light, we can easily get a light level that allows for a shutter speed of one second or more. We do not lower the intensity by using a rheostat to lower the voltage to the filament lamp, as this will produce a colour shift. Nor do we use an LED attenuator that uses pulse width modification, as

Table 6: Strategies for reducing mechanical shutter movement

Process	Long shutter speed	Hat trick	Electronic flash
What is needed	Neutral density filters	Camera with bulb or T-shutter setting. Built-in illuminator	Flash which can be fired upon actuation of the shutter
Strategy	Reduce light intensity by adding neutral density filters over the field diaphragm. Use an exposure of 1sec or longer	* Block light from the illuminator with a card. Use shutter speed of B or T to open the shutter * Move the card to allow light to enter the camera * Expose the sensor for several seconds * Cover the illuminator with the card	Design the illuminator so the flash can supplement light from a built-in light source. When the camera shutter release button is pressed, the flash fires and overwhelms the ambient light
Exposure determination	Exposure can be automated by using aperture priority setting	Exposure cannot be automated	Exposure is determined by experimentation. It is possible to use the TTL flash exposure system
Suitable for photographing	Only stationary specimens	Only stationary specimens	All specimens

Table 7: Desirable features of an interchangeable lens camera

Digital SLR	Mirrorless camera	Purpose of feature
Mirror lock-up	Not needed	Mirror lock-up prevents vibration
Electronic first curtain shutter	Electronic first curtain shutter	Prevents vibration when photographing still photographs
Electronic first and electronic second curtain shutter. I do not know of any models with this feature for still photography	Electronic first and second curtain shutter. Only present in a few camera bodies	Not essential when shooting single shots. May be desirable when shooting bursts of shots at three to ten images per second
HD video	HD video	Provides high resolution movies. Generally live preview is available with this feature
4K video	4K video	The frame from these movies has enough pixels to provide sharp still photographs
HDMI port	HDMI port	Can be used to drive an HD television for convenient viewing of the specimen

this can result in stripes of uneven illumination.

Another strategy is to use an intense flash to provide a brilliant burst of light. The theory is that the flash is so bright it makes up the bulk of the exposure, and if its duration is sufficiently short, it will 'freeze' movement. In other words, the flash duration is so short that mechanical vibrations are not recorded. This type of illumination has the advantage of 'freezing' the movement of minute animals. In addition, the colour temperature from the flash closely matches daylight. If there is a disadvantage to the system, it is the time, expense and effort needed to assemble such a system. Nevertheless, Charles Kreb, winner of many photomicrography contests, uses this type of set-up and the quality of his work is proof of its merits.

We have put together a system using flash units and a mirror. The Zeiss standard series microscopes will accept a mirror, and it is possible to use a Sony flash with their cameras to illuminate the specimen. The mirror reflects the flash illuminant to the microscope's condenser. Exposure is determined by Sony's pre-flash TTL ('through the lens') system. The flash fires a brief burst of light, which is used to calculate the light intensity needed for taking a picture. The flash then fires a more intense flash following the pre-flash.

The problem with our set-up was its inconvenience. It is not possible to observe the specimen just prior to taking the picture. It should be noted that the Sony

flash was triggered by using a wireless system: we mention this because it does provide a potential alternative to illuminating live specimens. We abandoned these studies because we now use mirrorless cameras with EFCS, as this set-up provides the convenience of previewing the live specimen just prior to taking its picture.

If you are using a digital SLR, the mirror generates a tremendous jar when the camera is fired. With this type of camera, it is imperative that it has a provision to immobilize the mirror just prior to taking the exposure. In some cameras there is a mirror lock-up command or switch; in others, activating the self-timer for taking a still photograph will raise the mirror immediately after pressing the shutter release button. The mirror is locked up, and after a delay of two to ten seconds, the first curtain shutter is released. A listing of some of the strategies we use to reduce vibration is found in Table 6.

Since we have switched from digital SLRs to using mirrorless cameras, most of our experience is based on using Panasonic and Sony cameras. From this we have put together a list of camera features that we feel are the most desirable for photomicrography: see Table 7.

Coupling the Camera to the Microscope

When using a digital SLR or mirrorless camera for photomicrography, its lens is replaced with a microscope. The joining of camera to microscope is accomplished in one of two ways: either by non-contact coupling, or by direct coupling of the camera to the microscope.

Non-Contact Coupling

In non-contact coupling the camera is attached to a copy stand and a tube is attached to the camera body. The tube faces downwards, and it, together with the camera, is lowered until the bottom of the tube covers the upright phototube of the microscope. The tube may be a set of extension tubes or a bellows. Of the two, the bellows is the most flexible because its length can be adjusted. The camera's opaque body cap is transformed into a light trap by drilling a hole in the centre of the cap so that it is just larger in diameter than the vertical microscope tube. By positioning the microscope and camera properly, the latter can be lowered. The body cap is attached to the bottom of the bellows. Once in place, lower the camera and bellows over the eyepiece until the end of the bellows lies beneath the level of the eyepiece. Since the camera body is supported by the copy stand, shutter movement is dampened. There is no contact between the body cap and the microscope.

This apparatus has two components. The most important part is the copy stand for supporting the camera and bellows. It needs to be heavy, rigidly constructed, and made with high precision. Such a unit will be expensive if purchased new, but they do show up on online auction houses, keeping the cost down. We have put together this type of assembly by using the heavy stands by Bencher or Kaiser (RS-1). The camera with bellows is mounted on the copy stand. Having a stand with a vertical post and a counter-balanced camera holder makes it easy to align the camera and lower it and the bellows to the proper height. The bellows unit can be purchased either new or used. Since it is being used as an adjustable extension tube, there is no need to buy an expensive unit.

If the microscope is a finite tube length stand, the photographic tube should have a low power eyepiece (2x–5x) that projects the image up to the camera sensor. A good set of eyepieces to use for this work are the NKF series made by Olympus. The sturdier the stand, the more that vibration resulting from firing the shutter will be dampened.

The disadvantages of using the copy stand is that it takes up table space. Also, it is inconvenient if you need to shift the camera to a different microscope. Although you might think that one microscope would be sufficient for the task, many hobbyists and researchers will purchase multiple microscope stands dedicated for different tasks. Using a copy stand is

best suited to someone who will be taking pictures from a single microscope.

Although the modern infinity tube length microscopes can be used in this fashion, the manufacturers have designed their phototubes for direct mounting on the camera. Typically, this will have a C-mount fitting to accept a dedicated photomicrography camera, which provides, as mentioned earlier, a vibration-free photograph.

Direct Coupling of the Camera to the Microscope

The direct coupling of the camera to the microscope is convenient, but it requires that when taking the picture, the camera be vibration free. An adapter can be a tube for joining an interchangeable lens camera to the microscope, where one side attaches to the microscope tube and the opposite connects to the camera. In this situation, the camera body serves to provide the shutter and viewfinder. If the microscope is sturdy and a camera is used which has no mirror movement and a vibration-free shutter, you can simply fire the camera and record the picture.

Another strategy for connecting an interchangeable lens camera to the microscope is to use one of the photomicrography camera systems made by Nikon or Leitz. These units can still be found online. Typically, they have an optical viewfinder for focusing the camera, a vibration-free shutter, and an exposure meter. What makes these units useful to the photomicrographer is that the film carrier can be replaced with a modern interchangeable lens camera. For example, the Nikon PFM adapter (Fig. 33) is equipped with either the Nikon F mount or the Leica 39mm screw mount. Thus it can be used with either Nikon digital SLRs or the Leica digital range finder cameras. The Leitz MIKAS adapter is sold with either a Leica screw mount or its bayonet M-mount, so the Leica digital cameras can be used on it. There is also an adapter which allows the modern Leica cameras using the bayonet mount to accept the older screw-mount lenses. Today, with the correct adapter, these camera systems can accept mirrorless camera bodies.

Fig. 33 A Nikon PFM adapter showing its shutter speed scale and focusing telescope.

Both of these camera adapters can be mounted on a microscope with an outside tube diameter of 25mm. In both cases, the camera's optical viewfinder need not be used for focusing the microscope image; this is accomplished by using the adapter's focusing telescope.

The focusing telescope is on the side of the adapter, and light from the microscope's eyepiece is reflected to it by a prism. The view through this telescope has a reticule superimposed over the image for framing the specimen. To compensate for variations in eye strength, the adapter's focusing telescope is focused on the reticule. Once this appears sharp, the microscope controls are used to frame and focus on the subject. Intuitively, you might think that discerning the finest detail is the criterion for establishing focus, but this is not the case: instead, you shift your eye while viewing the reticule, and if the image does not move relative to the reticule, it is in focus.

When the time comes to take the picture, the prism is swung out of the light path and the shutter is actuated. The shutter speed is set on the adapter. Typically, the camera body is a simple light-tight box whose sole purpose is to hold the film. Exposure is controlled by the adapter's shutter. If you prefer to use a mirrorless camera, you have to decide if you should use the camera's shutter for taking the picture. If your camera has a mechanical shutter that will jar the camera and blur the image, then it should be used by locking it to its open setting. Most cameras will have a means for doing this. Once open, you can use the photomicrography adapter's shutter.

If your digital SLR has an electronic shutter which is vibration free, you can use it to take the photographs. In this case, the adapter's shutter is locked to its open position and the digital camera's shutter regulates the light falling on the sensor.

You need to be cautious when purchasing some of the new inexpensive adapters, as they may have inferior lenses that show concentric ring patterns when the image contrast is enhanced. The professional units made for scientific work are very expensive (they cost £600 or more), but they will not exhibit this defect. When buying optics, it is a good precaution to request return privileges.

Most of the older adapters were designed to be used with full frame cameras, and evenly illuminate a sensor 24 x 36 in area. Today, modern interchangeable lens cameras have smaller sensors that are less than 25.1 x 15.7 (APS-C). It is fortunate that many of these older adapters have relay lenses which reduce the power of the microscope eyepiece they are mounted on. This is necessary to ensure that the field of view captured by the sensor occupies a good portion of what is seen through the oculars. When using a modern infinity tube length microscope with wide field optics, we record using a 2.5x eyepiece with a full frame sensor, 1.7x with an APS-C camera, and a 1.25x eyepiece with the Four Thirds sensor camera.

When using microscopes of older designs, we have to evaluate the minimum magnification we wish to use with the camera. Depending on the objective lens, the field of view will not be equally sharp from centre to periphery, and under this condition, you will need to increase the magnification to the camera to crop out the unsharp regions. To record the largest – maximum – field of view, you need to choose objectives with the prefix 'plan' in their description: you should use planachromatic, planfluorite or planapochromatic objective lenses. One of the advantages of buying a modern infinity tube length microscope is

Fig. 34 A Nikon F adapter is a simple tube adapter with a 0.5x relay lens.

that their objectives have a wider flat field than the older objectives made for the 160 or 170mm tube length microscope.

An example of a simple tube adapter is the one made by Nikon. It has a 0.5 power relay lens, and was made to be attached to Nikon microscopes and cameras. One side of the tube has a collet for attaching to the microscope tube (Fig. 34); the other side has a Nikon bayonet mount. This adapter is still usable today, as many of the mirrorless cameras can be fitted with an adapter to mount on Nikon lenses and accessories. We use this adapter on our older microscopes that have a 25mm outside phototube diameter. When using a full frame camera we use a 10x eyepiece, and we use a 6x visual eyepiece when using an APS-C and a Four Thirds sensor camera. These Nikon adapters can be found on online auction houses, and we have paid, on average, £40 for them.

We have also worked with the now obsolete film camera adapters designed for microscopes. These are examples of complex adapters and are no longer manufactured. However, they can be found on online auction houses. Examples of these are the Nikon PFM and the Leitz MIKAS (Micro-Ibso) adapters. Functionally, these are the equivalent of an SLR in that they have their own optical viewfinder, a moving prism, and a shutter. An interchangeable light-tight box attaches to these and carries the photographic film. The box can be replaced with, in the case of Leitz, their rangefinder camera, and in the case of Nikon, their SLR. Almost all mirrorless cameras and many digital SLRs can be used on these adapters as well. These adapters have a relay lens that reduces the magnification of the eyepiece. For Nikon, the relay lens reduces the power of the microscope eyepiece by 0.5, and for Leitz, it reduces it by 0.3.

To use these units, you attach them to the vertical microscope tube. Optically, they are designed to work with an eyepiece. The Olympus NKF eyepiece will work with the Nikon adapter, but it will not fit the Leitz adapter. Note that the relay lens in these adapters will reduce the power of the eyepiece. Below are the steps to take in using these adapters:

USING COMPLEX ADAPTERS TO REDUCE CAMERA VIBRATION

Using these adapters for taking photographs is a multi-step process; however, for those who own vibration-prone cameras it may be helpful to take advantage of the lower vibration shutter of these adapters, and the ability to avoid vibration resulting from 'mirror slap'. To do this, these adapters are operated with cable releases. In the case of the Nikon PFM it is a single cable, while the Leitz MIKAS uses a dual cable release.

Leitz MIKAS sells a paired cable release where the two cables are tied together so they are depressed with a single plunger. This is nicely designed so you can 'programme' a delay in raising the prism and opening the shutter. This delay eliminates the jarring associated with raising the prism. However, if this is unavailable, you can simply use two single cable releases and manually execute the delay.

The Nikon adapter works with a single plunger. When depressed, it first moves the prism out of the light path. Continuing the pressure will actuate the shutter. The delay between raising the prism and firing the shutter depends on how rapidly the plunger is depressed.

In both adapters, the delay between moving the prism and firing the shutter has to be long enough to allow vibration to die out. The movement of the prism, if done vigorously, will create a jar. By using the cable release with delicacy, you can ensure the shutter will fire after the vibration from the prism movement has died out.

These adapters use a leaf-type shutter which generates less vibration than the focal plane shutter of digital SLRs. When buying these units, the shutter speed settings probably need to be adjusted to ensure the putative speed matches the setting on the adapter.

* Mount your camera on to the adapter. With mirrorless cameras you can buy a lens mount adapter to fit either the Leitz or Nikon adapter. The adapters are more difficult to attach to a digital SLR. The Nikon digital SLRs will of course fit the Nikon adapter
* Swing the adapter's prism out of the light path. Both the Nikon and Leitz adapters provide an attachment for a cable release for this purpose
* Use the adapter's B or T shutter setting, and open its shutter with a cable release. This allows light to pass through the adapter to the camera body
* The camera can now be activated to take the exposure

The cost of a new adapter to fit a digital SLR or a mirrorless camera on to a microscope can be as much as £500. Considering how expensive a new adapter is, it is worth considering using these older film adapters. Their optical quality is excellent, and they provide an affordable solution for mounting your camera on to a microscope. A couple of points should be mentioned in this regard: first, the Nikon PFM requires only a single cable release to move the prism and then to fire the shutter. In contrast, the Leitz adapter requires two cable releases: one to shift its prism, and the other to fire its shutter. We like the Nikon PFM's flexibility as the Olympus NKF eyepieces can be used with this unit. We like the Leitz's light weight, so when mounting these adapters on a microscope whose coarse focus raises the weight of the camera body and adapter, we will use the Leitz unit.

Attaching Cameras to Modern Microscopes

The older finite tube length microscopes have a common set of dimensions. Most of them have photographic ports whose outside diameter is about 25mm, and the camera adapters described in the previous section were designed to clamp to this tube size. An eyepiece for visual work is inserted in the tube and projects

Fig. 35 The MeCan camera adapter fits a C-mount of a microscope's trinocular head.

a real image to the digital sensor.

By contrast, modern microscopes use a proprietary camera tube whose diameter is greater than 25mm. In most cases, the camera tube has a C-mount on top. This is a male thread of about 25mm in diameter for mounting video and electronic cameras. Its specifications are similar to those used in movie film cameras. The C-mount's inner diameter is too small to directly

mount cameras whose sensor size is larger than 17.3 x 13mm (Four Thirds sensor). If a camera with an APS-C sensor – 23.6 x 15.7mm – is mounted, the recorded image will display vignetting, and this is worsened if the camera's sensor size is increased. Typically, these adapters are used with dedicated photomicrography cameras whose overall sensor size is smaller than 17.3 x 13mm.

To get around this, we have used the adapters from Martin Microscope Company (http://www.martinmicroscope.com) and MeCan (http://www.mecanusa.com/DigiCamAdapter/index.htm) (Fig. 35). These mount on the microscope's C-mount fitting. This is a versatile solution because the adapter can be used on virtually any modern microscope, and it is handy when you need to switch from a low-light C-mount camera to an interchangeable lens camera for taking brightfield images. The MeCan and Martin Microscope adapters use threads for T-mount. A T-ring screws on to these threads, and these rings are customized so as to fit any interchangeable lens camera: a Nikon, Canon, Sony, or Panasonic camera can be fitted to these adapters. Both adapters work well with full frame cameras. They have an internal relay lens which multiplies the objective power by 2.5x. Higher power relay lenses can be purchased for the APS-C and Four Thirds sized sensors. When used with a mirrorless camera with an electronic first curtain shutter, vibration-free photographs can be taken.

Problems with Interchangeable Lens Cameras

The major problem of using a digital SLR camera for photomicrography is vibration. Sensor movement while recording an image will destroy the crisp delineation of fine structure. In a digital SLR, the rapid acceleration and braking of its swinging mirror creates vibration that can persist throughout the time it takes to expose the sensor. An additional but less severe source of vibration is the acceleration and breaking of the mechanical first curtain shutter. In the case of mirrorless cameras, problems resulting from the action of the instant return mirror are absent; however, many of these cameras still have mechanical shutters.

Fortunately this vibration is temporary and lasts only a fraction of a second. A simple way to avoid its detrimental effects on image sharpness is to use long exposure times. This works if vibration is temporary and the bulk of the light used to record the image occurs when the camera is motionless. For example, if vibration persists for $1/60$ sec, then reducing the light so as to require a 1 sec exposure will ensure that its blurring effect only makes up 1.67 per cent of the image. Essentially, the temporal portion of its contribution for recording the image is so slight that it is masked by the 99.33 per cent of the light that falls on the sensor after the vibration has died out. It is difficult to predict the severity of vibration with any given microscope camera. The microscope's weight, its stability, and the rigidity of the camera mounting system all play a role in determining their resistance to vibration.

The most convenient way to prevent mirror slap is to use either a mirrorless camera, or one with a fixed semi-transparent mirror (Sony SLT series cameras). If you have a digital SLR instead, it may have a control or command for locking the mirror; this may be either a mechanical switch that lifts the mirror out of the light path, or a menu command. In some camera models it may be a hidden feature. For example, some cameras when triggered with a delayed shutter command will first lock up the mirror before actuating the shutter. If the delay is long enough the vibration should die out before the shutter is actuated.

Dedicated Cameras

For the purposes of this book, a dedicated digital camera is defined as one that requires a computer for controlling exposure and storing the image. These cameras are not designed for handheld photography but must be mounted on to a microscope (Fig. 36). Their use is integrated with a computer which provides the preview screen for framing and composing the

Table 8: Comparison of sensor designations and their actual size

Sensor description	Diagonal mm	Width mm	Height mm
$1/3$ in	6	4.8	3.6
$1/2$ in	8	6.4	4.8
$2/3$ in	11	8.8	6.6
1 in	16	12.8	9.6
Four Thirds	22.5	18	13.5
APS-C	28.4	23.7	15.7
Full frame	43.3	36	24

subject as well as the operational controls for exposure, contrast and white balance. Picture files are stored on the computer, and the typical arrangement is to serially transfer data from camera to computer. Typically, the cameras are meant to be mounted via a C-mount on a photo tube, and are designed to work with a small sensor of 0.6 to 3.2 megapixels. Such cameras are advantageous when working under low light conditions such as working with fluorescence.

Mounting these cameras is complicated by their small sensors. They require an eyepiece projection lens that provides less than 1 power. The manufacturers use a sizing classification of C-mount sensors retained from the days when tube cameras were used to capture video images. These sensors are significantly smaller than the sensors used in digital SLRs or mirrorless cameras (see Table 8). The sensors are described in inches, and can be a $2/3$ in, $1/2$ in or a $1/3$ in sensor. Depending on the sensor you have in your camera, you need to select a suitable projection magnification. For example, Meiji Techno recommends 0.3x for a $1/3$ in, 0.5x for a $1/2$ in, and 0.7x for a $2/3$ in.

Fig. 36 The Tucsen DigiRetina 16 is a dedicated photomicrography camera attached via a C-mount.

Communication with the Computer

The earliest dedicated cameras required a specialized image capture card mounted within a desktop computer. Today, most dedicated cameras can be used with a laptop computer and communicate via a USB port. The computer screen receives an image from the camera. Normally the images are updated at thirty frames per second, and this is fast enough for movement to appear fluid. If the subject moves or the microscopist changes focus, the view in the screen updates quickly enough so that the changes occur in real time. Slow updates occur under low light conditions with exposures longer than $1/30$ second.

The screen's refresh rate is delayed when a photograph is taken using long shutter speed duration. For example, if the exposure is half a second, the screen will only be updated twice in one second. This is a problem when one needs to move the specimen or to focus, because then, motion does not appear smooth but occurs in jumps, making it difficult to find focus or to frame the image. For easy framing and focusing, a shutter speed shorter than a quarter second should be used.

The refresh of the screen may be delayed by the transmission rate of the USB port. There are two speeds: the slower speed is USB 2.0, while the faster speed is USB 3.0. For cameras having a pixel count of two megapixels, the 2.0 protocol is sufficient to support a refresh of thirty frames per second (fps). Higher pixel count cameras transmit so much data that the computer screen cannot be refreshed at this rate. For example, when working with an eight-megapixel sensor, we found the dedicated camera would refresh the screen at about two fps when using a USB 2.0 port. The refresh rate became fifteen fps when using a USB 3.0 port. Even though the USB 3.0 port data transmission rate is ten times greater than USB 2.0, it still could not provide enough throughput to refresh the screen at thirty fps.

To take advantage of the potential USB 3.0, the camera has to be designed to work with this standard. The data flow will be bottlenecked by the slowest protocol, so there is no point in using a USB 3.0 camera on a computer that has only USB 2.0 ports. Similarly, the reverse is true, and the computer with a USB 3.0 port will not receive data any faster if the camera only supports USB 2.0. Keep in mind that many laptops are sold with a mix of USB 2.0 and USB 3.0 ports. The appearance of the ports is similar, so take care to ensure that the fastest port is being used.

One serial interface that was used for connecting the cameras to computers was the FireWire (IEE 1394 high speed serial bus). Examples of this type of camera are the Optronics' MicroFire and MacroFire cameras. You may still buy these cameras even though the vendor no longer manufactures them. However, if you choose to buy them, you must make sure that your computer supports the FireWire protocol. This serial protocol is less common than USB and you may have to modify your machine. With desktop machines this can usually be accomplished by buying a FireWire card and inserting it into the computer case. With a laptop computer, you will probably have to make sure it has a PMCIA card slot. There are accessory cards which can be inserted into this slot to give the computer USB 3.0 or FireWire capability.

A user of these cameras must always be aware that they will need good support from both the camera and the computer manufacturers. When the operating system is upgraded, it is possible to discover that the camera and its software will no longer function. This is one reason why research scientists were reluctant to upgrade from Windows XP.

Imaging with Dedicated Cameras

As a general rule, the sensors on dedicated digital cameras are more sensitive to light and have a greater dynamic range than the sensors found on digital SLRs and mirrorless cameras. This is because their photosites are larger, so they have greater dynamic range and lower levels of noise. In addition, an electronic cooler (Peltier device) is often used to reduce their

temperature and lessen thermally induced noise. This ensures the photosites do not give a false positive signal. Many of these scientific grade cameras are black-and-white only, which provides for greater sensitivity to light and higher resolution. Manufacturers of dedicated cameras have a high quality control standard, and reject thousands of sensors to ensure that only the best is used for their product. Such cameras may cost in the tens of thousands of pounds sterling. While such high standards seem exorbitant for one whose goal is simply to take pictures, it is necessary for certain types of scientific research.

Controlling the Captured Image

Dedicated cameras have a region of interest (ROI) command for demarcating a specific region on the image where the camera can perform image-processing applications or measurements. For those of you familiar with Photoshop, this is analogous to its selection tool. Unlike Photoshop, which works on saved images, this operation is done during the live preview. By restricting the amount of data to be manipulated, the software can perform mathematically intense operations while collecting an image. For example, you may select a 512 x 512 pixel array and perform image processing on just that region, rather than the entire field of view.

For photomicrography, the ROI feature is used frequently as a spot meter. A small region within the image is marked, and the intensity within the defined area determined. The area can be sized,shaped and positioned as needed. This is advantageous when working with specimens that are bright against a black background, such as occurs when doing florescence or darkfield microscopy. It also works in reverse and can be helpful when working with stained sections. For these, the clear areas not having tissue can pass so much light that they mislead the light meter. With the ROI feature you select just the area containing tissue, and base the exposure from this. ROI is useful for white balance determinations. Again, when working with a stained preparation, the coloured tissue can bias the white balance measurement. By selecting an area free of tissue, you adjust the white balance without this influence.

Dedicated cameras treat the image as a quantitative data set which can be manipulated mathematically. A good example of this is flat field correction, an operation that corrects for uneven illumination. This is done mathematically by subtracting a reference image from one having the subject. The reference image is taken without a specimen in the field of view, and serves to record defects generated by the microscope optics. For example, there may be vignetting: the corners of the field of view appear darker than the centre; in addition, the microscope's lens may have dust, and these defects can be projected on to the sensor as out-of-focus shadows. These artefacts may be subtle and not detected by visual inspection of the monitor. However, they can become apparent when aggressive image-processing techniques are used to enhance contrast. For example, the experiments showing single strands of microtubules with the light microscope make these defects readily apparent. To avoid this, the microscopist subtracts the calibration image from the image of the specimen, and this masks the defects. The recorded image, after contrast enhancement, will not show vignetting or dirt.

This type of correction is not used as a replacement to maintaining clean microscope optics. Lenses have to be kept scrupulously cleaned. If dust is readily apparent in observing the image without enhancement, this type of manipulation cannot remove its appearance.

Greater Control through Binning and Gain

In consumer-grade cameras, the photographer can reduce the number of pixels when saving a picture. For example, a 6000 x 4000 pixel array (twenty-four megapixels) image may be resized and saved as a

3000 x 2000 pixel file (six megapixels). The same thing can be done with dedicated cameras, but with a more advanced twist. The signal generated by the 2 x 2 pixel array is combined to generate a single signal: it is as if the 2 x 2 pixels have become one large pixel whose sides have doubled in length and whose surface area has quadrupled. This is an example of binning.

Binning has the benefit of providing an increased signal for a selected shutter speed. If you wish to maintain a given signal output, binning allows you to use a shorter shutter speed. To illustrate this, consider a sensor having 2048 x 2048 pixels (four megapixels), and its output is binned by combining four pixels into one. The sensor operates as if it is 1024 x 1024 pixels (one megapixel). Doing this increases the camera's sensitivity by 4x and allows a reduction in exposure from four seconds to one second. There is a loss of resolution; however, this may be tolerated when working with faint samples.

In point of fact, with well designed software, the photomicrographer can have his cake and eat it, too. To keep the shutter speed to a short duration, binning is used to preview the image. With the short shutter speed it is easier to frame and focus the image. When the time comes to take the picture the camera turns off binning and takes the picture with a longer shutter duration. In this way, one has the benefit of binning for previewing the image under low light conditions, and recording the image without a decrease in resolution. In other words, binning is done in live preview, but when the picture is taken, it is turned off and the picture is recorded at full resolution by using a longer exposure duration.

To illustrate this point, imagine a sample that requires a four-second exposure without binning. This cannot be used for focusing because there is a four-second delay between turning the fine focus knob and seeing its results on your computer display. This delay makes it impossible to establish focus. But if you can do a 2 x 2 binning, you can achieve a refresh speed of a quarter second. This provides a fast enough update that you can evaluate focus when turning the knobs. If the software is well designed, when you snap the picture the camera stops binning and records the image with a four-second exposure.

Many dedicated cameras allow binning for the live preview window and provide this advantage. Furthermore, in addition to using binning, you can change the gain of the sensor. If the sample is too dim to view, you can change the sensor's gain with a keyboard or mouse command. This brightens the preview screen, albeit with increased noise. Like binning, setting the gain is a useful command to have when working with faint samples. Although interchangeable lens cameras allow you to raise the ISO, this is not really the same command. Again, like binning, a well designed dedicated camera will allow you to view the specimen at a high gain setting with a short exposure duration. When the time comes to take the picture, the gain will drop and the shutter stays open longer and this allows the capture of an image with lower noise levels.

Gain and binning are valuable features when working with low light levels. The commands are additive in that you can use both for viewing very faint samples. Indeed, a good dedicated camera will allow you to view specimens so faint that you cannot see them by direct visual observation through the oculars.

Sensor Array and Magnification

For microscopists interested in producing large photographic prints, the dedicated camera's greatest limitation is its pixel count. The majority of these cameras have sensors with fewer than four megapixels. Since Sony, Canon and Nikon have full frame sensors with twenty-four megapixels or greater, this would appear to be a major deficiency. However, this is not the case in technical work. For publication, most prints are made to fit a journal's format, and this may be smaller than 4 x 5in.

To get the best results with dedicated cameras, you have to make every pixel count. The image is framed to the sensor's edges so the entire sensor area is used. If the image is too small, it cannot be enlarged since there are too few pixels, and digitally enlarging the

image quickly reaches a point were the individual pixels are discernible.

When working with a limited number of pixels, a magnification changer is invaluable for correctly sizing the image. Many of these changers are accessories that mount between the objective and the camera. An example of one that fits between the nosepiece and eyepiece is the Zeiss Optovar. It is a cylindrical housing that contains a rotating disc. This disc is fitted with various lenses for varying the magnification, and by rotating this disc, the objective powers can be increased from 1.0x to 1.25x, 1.6x and 2.0x. This allows the microscopist to vary the power by 0.25x.

To illustrate the importance of the above point, keep in mind that we need 300 pixels per inch to make a publication quality product. So a camera sensor with the 1200 x 1500 pixel array can make a 4 x 5in print. But suppose you're using a 40x objective and find that it provides just a little too much magnification and crops out a small portion of the subject. If you use a 20x objective lens to reduce the magnification to frame the whole image, your specimen occupies an area of 600 x 750 pixels. This is suitable for making a 2 x 2.5in print. If you have a magnification changer, you may be able to frame the specimen by using a 20x objective lens and a 1.6 power supplementary magnification that covers an array of 960 x 1200 pixels. This can make a print of 3.2 x 4.0in. Such fine increases in magnification are only obtainable with a magnification changer, and ensure that you can fill the sensor's field of view with the subject.

Although it is possible to add eyepieces to the phototube to provide a gradual increase in magnification, this is seldom done because it is inconvenient. You have to remove the camera, change the eyepiece, and then reattach the camera, all of which disrupts work flow.

Conclusion

In a perfect world you would have a variety of cameras to undertake a photomicrography assignment. Unfortunately this is seldom possible, and you have to select a universal microscope camera. For many of us the most affordable set-up is modifying a digital SLR or a mirrorless camera for the microscope. The main problem with both of these cameras is that they were not designed for this work, and their design can circumvent the taking of sharp images.

The chief problem is the creation of vibration during the point of exposure. Fortunately this can be avoided with certain techniques. Either using a long or a very short shutter duration may be the solution to this problem. Vibration-free operation is most easily obtained in today's mirrorless cameras. With the development of an all-electronic shutter, these cameras can be vibration free when they take a picture. However, this feature is not found in all models of mirrorless camera, and the photomicrographer may still have to face vibration induced by the action of their mechanical shutters.

The dedicated photomicrography camera features this all-electronic shutter capability. In addition, because they use a computer and its monitor for controlling and viewing the specimen, these cameras are particularly convenient to use.

CHAPTER FIVE

DIGITAL CONCEPTS

The taking of a picture does not capture all the nuances of detail and colour; instead, the process of digitation simplifies the image into quantifiable units. This places a fundamental limit on how much information can be recorded. A digital camera image quantifies light intensity values and assigns it to a position within a matrix identified by a Cartesian coordinate system. Intensity is assigned a numeric value so that simple arithmetic operations can be performed. Depending on the quality of the data, more complex algorithms can be employed. An example of such a process is deconvolution, which eliminates the glow from out-of-focus structures. This is accomplished by gathering intensity values of the specimen by focusing up and down its thickness. A complex algorithm then attempts to assign each photon to its place of origin. If performed properly, the image will present a sharp, contrasty image in three-dimensional space.

There are three variables that the digital photographer must take into account when buying a camera. The first is the overall size of the sensor, which may range from 17mm² (3.6 x 4.8mm) to 864mm² (24 x 36mm). The projected image must be enlarged enough so that it covers the sensor. A larger circle is needed to cover the 860mm² sensor than the 17mm² sensor. In other words, more magnification is needed for the larger sensor than for a smaller one. The second variable is the number of pixels contained within the sensor; this determines the fineness of detail that can be recorded. The final component is the size of the photosite or pixel that captures the light. Larger photosites provide a more accurate quantifying of light intensity.

These three variables influence the type and quality of pictures that are recorded. For a given sensor size, a larger photosite means there will be less resolving power. This is offset by an increased accuracy in quantifying light intensity. Also, choosing a sensor with a larger overall size will increase the exposure needed to acquire an image. For every doubling of the diameter of the imaging circle, light intensity on the sensor drops and you will need to increase the exposure four times. In other words, if you want to use a large sensor with a large pixel count, you need to work with a subject that can be illuminated brightly. If you are working under low light conditions, such as fluorescence or darkfield lighting, a smaller overall sensor size is more desirable. This is because the imaging circle is less, and less magnification is required to illuminate this sensor. By halving the sensor size, you can decrease exposure four times.

The Number of Pixels

The image recorded by the sensor has to be enlarged to be viewed (Fig. 37). How much this can be done is dependent on the number of photosites in the sensor. It is possible to magnify so much that the individual pixels are seen as discrete squares (Fig. 38). The number of pixels required to make a good picture depends on its intended use. In scientific journals, many publishers request that pictures have 300 pixels per inch. In part, this value is determined by the method of generating a plate for printing. Thus a square sensor with 900 pixels per side can be used to make a publication quality print 3 x 3in. If an image has 1800 pixels per side, it can be enlarged to 6 x 6in.

DIGITAL CONCEPTS

Fig. 37 Digital pictures are composed of pixels that are indiscernible when viewed at low power; however, they can be seen if the image is greatly enlarged.

Fig. 38 Enlargement of Fig. 37, showing how it is comprised of square pixels.

Many photographers are concerned with resolution, and naturally want the sharpest, most detailed image. This results in the quest for sensors containing more pixels. A confusing aspect of choosing high resolving sensors is that the manufacturers describe the entire pixel count as a camera specification. Unfortunately, comparing pixel counts between camera sensors does not reflect their differing performance. It is important to realize that resolution improvements are best described by the increase in pixel counts along a line. In contrast, the sensor count is an area measurement that multiplies the number of pixels spanning the width and length of the sensor. In other words, for the resolution to increase by two, the pixel count has to increase by four. To get a doubling of resolution from a four-megapixel sensor requires that one obtain a sixteen-megapixel sensor. The disparity between resolution and pixel count is shown in Table 9.

The sensors' pixel counts vary over a large range. There are scientific cameras with only 512 x 512 pixel arrays, and there are digital SLR cameras with 8688 x 5792 pixel arrays. The pixel count in the array is determined by multiplying the two numbers together, giv-

Table 9: Resolution is a linear measure. However, sensors are described by how many pixels are in the sensor. To double the resolution of a 16.7-megapixel sensor requires obtaining a 67.1-megapixel sensor

Resolution array	Square pixel	Pixel count	Mega-pixel
1x	512 x 512	262,144	0.26
2x	1024 x 1024	1,048,576	1
4x	2048 x 2048	4,194,304	4.1
8x	4096 x 4096	16,777,216	16.7
9x	4608 x 4608	21,233,664	21.2
16x	8192 x 8192	67,108,864	67.1

ing a total of 262,144 for the former and 50,000,000 for the latter. With such large numbers, it is easier to express the counts in millions of pixels. In this case, the sensors are described as having 0.26 megapixels and fifty megapixels respectively.

With the push for higher resolution, it is evident that for a given overall sensor size, the only way to have more pixels in the sensor, is for the pixels to become smaller.

Pixel Size and Light

When intensive image processing is anticipated, precision and accuracy in measuring light intensity becomes more important than resolution. In comparison to a small photosite, the larger one is better suited for quantifying light. Essentially, the larger photosite can accumulate more photons for generating an electrical signal. This allows for a greater dynamic range and a higher signal-to-noise ratio. If one wants to have both a high pixel count and maintain accuracy in light measurement, the overall sensor size must be increased. This is the reason professional photographers who use digital SLRs or mirrorless cameras are interested in upgrading from the smaller APS-C to full frame sensors.

In order to record an image, each photosite records light and generates an electrical signal, which is digitized. These are expressed as powers to the base 2. At its most basic, an image can be digitized to a one-bit range: there is either light or there is not. An example of this is black text on a white page. A one-bit range will accurately record or display print. To display the grey levels of the image, collecting eight bits (256 grey levels) will generate an image showing a range of intensities (Fig. 39). If too few bits are used to collect the image, grey levels will be lost: this can be seen in Fig. 40.

Black-and-white images can be recorded and displayed as eight-bit images. An eight-bit (2^8) has 256 intensity levels, with 0 representing absolute black and 255 representing absolute white. Cameras can digitize the data to higher bit levels, and it is not

Fig 39 A testcard image rendered as an eight-bit image with 256 grey levels.

Fig 40 The same testcard rendered as a six-bit, or sixty-four grey levels.

uncommon for cameras to digitize to fourteen bits (16,384 grey levels). If too few bits are used to digitize the picture, it will not be rendered as a continuous grey tone: instead there will be 'jumps' in intensities. This is illustrated in Fig. 40, which is rendered as a six-bit image with sixty-four shades of grey, while Fig. 40 is rendered as an eight-bit image with 256 shades of grey.

Although eight-bit depth range refers to the span of intensities that can be recorded, this entire range may not be captured. For example, an eight-bit camera can record an image having only 128 grey levels out of the 256 possible. When this is displayed on a computer, the image appears to be of low contrast. How-

ever, computer enhancement can take this low contrast image by using a LUT ('look up table') to reassign intensity values for making a high contrast image. To envisage this, imagine a diatom mounted on a slide. Its clear frustule (silica shell) has little contrast – it has neither jet-black shadows, nor a brilliant white highlight. Instead the image appears flat. The recorded intensity range of this image may span only 128 grey levels, with the darkest part of the diatom at 64 and its brightest part at 192. With this digitized image, it is possible to reassign the 64 value to 0 and assign the 192 value to 255. The intermediate intensities from 64 to 192 are mathematically assigned new intensity values.

A problem about reassigning these values is the appearance of gaps between the intensity values. When intensity values have been reassigned, this leads to an increased separation in their values. The original image has a continuous histogram, while the new one, of higher contrast, has a discontinuous one. On the monitor, the diatom will now have its darkest regions displayed as black (level 0) and its brightest regions displayed as white (level 255). This will create an impression of greater contrast.

To fully exploit this expansion of the histogram one needs cameras that can digitize their data to a range of eight bits. If the contrast enhancement has to be extreme, it is better if the camera can digitize to even higher bit levels. Many digital SLRs, for example, will digitize to twelve bits.

Solid-state detectors absorb light and generate an electrical signal proportional to the light collected. Larger photosites accumulate more charge, thereby recording a higher intensity of light. As a result, they can accurately measure higher light intensities that in turn increase the measurable dynamic range. To illustrate this point, the detector can be viewed as a bucket and the light as the water droplets (photons) that are falling into the bucket. A larger bucket can capture more water. If you use a bucket that can hold 4,000ml it will, in comparison to a bucket of 1,000ml, hold four times the amount of water. In terms of dynamic range, this is four times greater. If one uses a ml as a unit of measure, one has a dynamic range of 0ml to 4,000ml. In contrast, the 1,000ml bucket has a range from 0ml to 1,000ml. In terms of photography, the larger sensor can quantify a larger range of intensities.

This greater capacity also allows for greater precision in measurement. The 4,000ml bucket can measure a drop to 1 in 4,000, while a 1,000ml bucket can measure a drop to 1 in 1,000. There is a 4x increase in precision.

This discussion of photosite size is significant because there is a balance between accurately measuring the light, and determining the delicacy of detail that can be recorded. Many digital photographers lose sight of this by being concerned only with the megapixel count. This is understandable since it is easy to think in terms of spatial information that is encoded in the image. For example, a twelve-megapixel camera can record finer detail than a six-megapixel camera. However, the quality of the light measurement is independent of the pixel count. Instead, it is dependent on the size of the individual photosite. This is a subtle aspect of image quality, and it determines the accuracy with which the light is measured. Accurate light measurement is critical if you are doing quantitative analysis or extensive image processing.

Many photographers are concerned with recording and documenting images, and the ultimate accuracy in quantifying light is not a priority. Since the overall size of the camera's sensor is fixed, increasing the pixel count is accomplished by reducing individual photosite size. Therefore, to attain greater spatial detail, you sacrifice the accuracy and precision with which light is recorded. The only means to increase pixel count and retain performance is to expand the overall size of the array. This is the justification for developing larger-sensor cameras.

For general photography, the advantages of using the larger photosites can be demonstrated by comparing the performance of the Sony a7S camera with their a7 II. The former has a twelve-megapixel sensor while the latter has a twenty-four megapixel sensor. The larger photosites in the a7S allow it to capture images illuminated by moonlight. These photographs exhibit with much lower grain than those captured by the higher pixel count Sony a7 II. It should be noted

that this difference in performance is most obvious in low-light conditions. When illumination is intense, such as with brightfield microscopy, the loss of performance in smaller photosites is not so obvious.

Pixel (Photosite) Size and Resolution

When doing research work, the photomicrographer must remember that the camera is a sampling device that can limit the microscope's ability to record fine detail. If the photosite is so large that two points of light fall on it, these points won't be recorded as being spatially separated. To detect two objects as being separate, each one must fall on a different photosite. In addition, there has to be at least one pixel separating the two photosites. When choosing a camera, you must make sure that its pixels are spaced at an interval that ensures there is this separation.

For a microscopist who already owns a camera, the most direct way to ensure the separation of the two pixels is to magnify the image. As one increases the magnification on to the sensor, the two points will become more widely separated. This is shown in Fig. 41. When the magnification is low, two points can be projected on to a single pixel. This pixel will generate an electrical signal, but the camera will detect only one point, not two. The electrical signal is seen as the cyan background. As one raises the magnification to the sensor, the two points will fall on different photosites. The critical question is how many spacer photosites are needed to indicate that two objects are separate. Operationally, the points being projected on to the sensor are separated as the magnification is increased.

To determine how much magnification is needed to resolve two structures, we will use the Nyquist criterion. This specification is based on treating data as a frequency, and it calculates the pixel sampling frequency needed to accurately record the initial data. Keep in mind that the rigorous application of this formula is for the 'best' case scenario. In terms of digital sensors, there are variations in their capabilities, and defining their sample frequency is complicated. It does not help that a digital sensor is an imperfect device for collecting spatial data. Remember photosites are shaped as squares, and the putative resolving power will depend on the specimen's orientation to that structure. Resolution will be higher for those areas running parallel to the borders of the frame, and will be less when the structures are running diagonally. In addition, some sensors have a low-pass filter, which reduces their resolving power. This is essentially a 'blurring' device, which prevents moiré. Finally, if you use a colour camera, the Bayer mask requires a sampling of four adjacent pixels to assign a colour value to one pixel. In comparison to a black-and-white camera, this reduces resolution by 30 per cent.

Theoretically, two photosites should be the minimum needed for a spacer. Practically, especially for a colour camera, we found three photosites to be a more realistic value for defining a minimum spacer. Given that three photosite spacers are needed to detect two points as being separate, we developed a working equation for estimating the amount of magnification needed to resolve two spots. This equation requires that we know the objective lens's NA and the size of the photosite. We transformed the standard equations for resolution working on the assumption that three 'spacer' pixels are needed to ensure that

Fig. 41 The squares represent photosites, and the purple dots represent objects to be detected by the sensor. In the diagram, a photosite that is generating an electrical signal is coloured blue.

two points are resolved.

First we use the equation for determining optical resolution of an objective:

$$MRD = \frac{0.61\lambda}{NA}$$

Where:
MRD is the 'minimum resolved distance'
λ is the wavelength of light used to observe the specimen
NA is the numerical aperture of the objective lens

Since the microscope is projecting an image of the specimen on to the sensor, we have to account for its magnification. We created a new term: P for the pixel size in µm needed to resolve the details we wish to record. This takes the MRD and divides it by three, representing the need for three pixel spacers, to determine the value of P. At this time the equation has not taken into account magnification. We are treating P as a 'virtual' pixel in that we are visualizing it as occupying the size of the MRD without any magnification. To take into account magnification, we have to divide P by the magnification of the microscope. Since the theoretical size of P is dependent on the image being projected on to the sensor by the microscope, we multiply by the Mag (power of the objective lens x the power of the relay lens x the magnification changer's factor).

$$P = \left(\frac{MRD}{3}\right) Mag$$

Expand MRD with the following equation:

$$MRD = \frac{0.61\lambda}{NA}$$

The equation becomes:

$$P = \frac{\left(\frac{0.61\lambda}{NA}\right)}{3} Mag$$

If we set to

$$P = \left(\frac{0.11}{NA}\right) Mag$$

the equation now becomes:

$$P = \left(\frac{0.11}{NA}\right) Mag$$

Rearranging the equation, gives

$$Mag = \left(\frac{NA}{0.11}\right) P$$

These last two equations are a useful reference when working with digital sensors. The equation solving for P provides the determination of the pixel size when you know the NA and the projection magnification to the sensor. It provides a guide as to what camera you should use. Once you have selected a camera, the last equation for Mag is used to determine what power you should use to record the fine details revealed by the objective. For example, if we use a 1.4 NA objective and its Mag is 100x, P equals 7.9 µm. What this means is that to obtain the full resolution of this lens, you must use a camera whose photosites are 7.9 microns or less in size. In comparison, if you have an objective lens that is 60x with an NA of 1.4, to record the full resolution of this objective you will need a camera whose photosite size is less than 4.8 µm.

We use this equation to determine if our full frame cameras are suitable for our microscope. For example, many full frame sensor adapters use a 2.5x relay lens to project to the sensor. So if we have a 10x objective, the magnification to the sensor will be 25x. Using the equation above, if we use a lens with an NA of 0.4, we can calculate that the desired pixel size will be 7 µm. The full frame sensor Sony a7 camera has photosites of approximately 6.0 µm. Here we get a nice match where the full resolution of the objective is matched to the sensor. If we choose to use a Sony a7S camera which has a sensor whose photosites are 8 µm, we are undersampling the specimen, meaning the sensor is limiting us from recording all the fine detail that the lens can resolve. If we use the Sony a7R II, whose pixel site has a size of 4.5 µm, we are oversampling the image. This means our sensor has sufficiently small pixels to record the full resolving power of the lens.

The situation can be critical for higher power objectives. Earlier in this section we calculated that a 100x objective with an NA of 1.4 required a camera whose photosite is 7.9 µm to record its resolution capabilities. This means a Sony a7S with its 7 µm photosite is perfect for this task. However, if we use a 60x objective with an NA of 1.4, the fine details recorded with the previous 100x objective will not be recorded when using this camera. We need to use the Sony a7R II with its 4.5 µm photosite to capture the full resolving

ASSUMPTIONS FOR THE EQUATION

The reader may be wondering about the rationale we used for selecting the equation constants for determining the needed magnification and pixel size. First, in terms of wavelength λ, 550nm is green light and is the wavelength for which achromatic objectives are corrected for spherical aberration. It is also the wavelength of light to which the human eye is most sensitive for high resolution imaging.

We used three pixels as the requirement needed to resolve two points as being separated. This was based on personal experience, when we found that a three-pixel separation provided enough separation to allow us to record what we could see in the eyepieces. If we have too many pixels between the two detecting points, then we have the condition of oversampling. For imaging, oversampling is not a bad thing because it guarantees the recording of the fine detail at the expense of creating larger digital files.

Theoretically, the Nyquist criterion would suggest that only two pixels are needed for this separation. We did not observe this; however, it may reflect that the photosites in our camera sensors are not the best for high resolution imaging. First, many sensors have a low pass filter, which blurs the image. This helps prevent moiré for colour sensors. Secondly, the Bayer mask on colour sensors reduces spatial resolution by about 30 per cent. In any case, our decision to use three pixels was a pragmatic rather than a theoretical decision.

power of the 60x objective. In other words, the camera can limit your ability to record the full resolving power of your lens. This is one reason we have a magnification changer on our microscope. When using a 60x NA 1.40 objective with a Sony a7S, we will set the magnification changer to 1.6x. This will increase the magnification of the 60x objective to 96x. This higher power will allow the Sony a7S to record the finest details revealed by this lens.

Once you know the size of your camera's photosites and determine the camera's useful magnification, you can determine at what point you are using empty magnification. That is to say, you will find the upper limit of usable magnification. If you use magnification greater than this, your sensor will not record any finer detail. Your resolution is limited by the optics of your microscope.

Colour Images and Additive Colour

Some microscope techniques record their images in monochromatic light and use a black-and-white camera. For example, differential interference contrast and phase contrast work generate their highest contrast and sharpest images when using a green filter in their optical system. Under these conditions, black-and-white images are more pleasing than an image with an overall green colour. In fluorescence work, the filters select a specific wavelength of light to be transmitted to the sensor.

However, this is not how we see most things. We are endowed with colour vision, and the tints and hues of a subject are important for appreciating its beauty.

Fig. 42 Three colours – red, green and blue – can be used to generate a full colour image.

Moreover, for clinical work, the staining of histological sections imparts a colour, and this is important for distinguishing nuclei from the cell body. To record these hues, cameras, which are monochromatic, have to be designed to record the relative ratios of red, green and blue light.

A direct way of providing colour information to a pixel is to take three exposures, each exposure being made with a filter containing one of the three primary colours. For example, one image is made with the red filter, another with the green filter, and the third with the blue filter (Fig. 42). This strategy is used by dedicated professional photomicrography cameras whose design is to provide the highest resolution image. When used to take colour photographs, these cameras have the same resolution as a black-and-white camera. The disadvantage in this design is the time lost by taking three separate exposures. This makes it impossible to record living, moving subjects. The bit depth of the coloured image is tripled when performing the above operation. If an eight-bit depth camera is used to capture each of the images taken with a coloured filter, each individual colour filter picture is eight bits and the resultant three-image combination is now twenty-four bits.

If the goal is to record living animals, it is necessary to capture the colour information simultaneously rather than sequentially. A design used by top-end professional camcorders or broadcast quality video cameras is to divide the image into three with a beam splitter. Each beam is targeted to one of three sensors, each having either a red, green or blue filter. When the image is recorded, the images are combined for a colour image. There is a loss of sensitivity because of the division of light, but it allows the recording of moving subjects. This strategy is not used by still cameras that record video.

For these cameras, a single sensor is overlaid with a coloured filter array. The most common of these arrays is the Bayer mask, which covers each pixel with either a red, green or blue filter (Fig. 43). Usually there are two green pixels for every blue and red pixel. This increases the sensor's sensitivity to green light in order to mimic the human eye's greater sensitivity to that colour. A single exposure captures all three of the primary colours,

Fig. 43 The pattern of coloured filters (Bayer mask) laid over a sensor array. Each colour square is a filter over one photosite providing colour information to the picture.

but at a sacrifice. Since four pixels are needed to collect the three primary colours, a 1024 x 1024 pixel array is reduced to a 256 x 256 array in terms of colour. Fortunately, the combining of these four pixels does not reduce resolution by a factor of four. In colour photographs resolution is reduced 30 per cent in comparison to a black-and-white sensor.

Camera Settings: File Format

The camera saves the image as a digital file. For mirrorless and digital SLR cameras there are two general file formats. The first is JPEG files (Joint Photographic Experts Group). These are compressed files where some data is lost when they are compacted. This is an example of a lossy compression. For scientific work and intensive image processing, JPEG files are undesirable. If you edit a JPEG file and then save it repeatedly an unpleasant phenomenon will occur: the fine details within the image will be gradually lost as the file is saved repeatedly. If you wish to archive these files, it is a good idea

to reserve one file that will not be edited. Instead, this file is copied and only its duplicate is image processed. In this manner, you will retain a file that maintains the full resolution. On personal computers, JPEG files can have the file extension of JPG or JPEG.

A better strategy is to save the files in the manufacturers' RAW format. This data is minimally processed and if compression is done, it is usually of the lossless type. That is to say, though the file is reduced in size, fine detail is not destroyed. Unfortunately it has the disadvantage of being proprietary, and not all image-processing software can work with it. One reason photographers need to update Photoshop is to maintain its ability to open RAW files for newly released cameras. However, Adobe only upgrades RAW compatibility with their current version of the program. In other words, you cannot open the RAW files from a camera if it is made after your last installed version of Photoshop.

To get around this, Adobe provides the program 'DNG converter', which converts RAW files to DNG (digital negatives) files. Older versions of Photoshop can then read these files, allowing their users to use the latest cameras. This is not ideal because it requires an additional step in your image-processing work flow. But at least the program is free and allows you to avoid paying a monthly fee to Adobe to use the latest version of Photoshop.

There are also third-party software packages for converting RAW files. One that we use is DxO Optics Pro. We use this for our regular photography, and it does an excellent job in reducing noise in the RAW files. Owners of new Apple computers are in a fortunate situation in that Apple provides RAW converters for their Preview App. This app can translate RAW files into a format such as sixteen-bit TIFF (see below) or JPG, and these two file formats can be read by any computer or image-processing software.

When working with digital dedicated photomicrography cameras dedicated for scientific work, you will be able to save files as either JPEG or TIFF ('tagged information file format'). TIFF are like RAW files in that they can be repeatedly opened and saved without losing data. They can be saved as either eight-bit or sixteen-bit. For most scientific work, sixteen-bit format is used.

Camera Settings: Focusing

If you are using a digital SLR, avoid using its optical viewfinder because the image projected on to the translucent screen is ill suited for focusing a microscope. Its coarse granularity destroys image sharpness. Worse, it is light inefficient, and the image is darkened to the extent that it is unusable for work with a fluorescent sample. Finally, the eyepiece is awkwardly placed: it faces the room's ceiling when the camera is mounted on a microscope.

A better strategy is to use a camera that generates an electronic image for previewing the scene. This is done on a small, solid-state monitor. Typically, this display has a diagonal measure of 2–3in, so it is too small to use for focusing without some electronic aids. If possible, try to use a camera whose display can be tilted so that its screen will face you when you are seated at the microscope. If that is unavailable, see if your camera has a port for driving an HD (high definition) television. With the right cabling, it will be possible to project the view from the camera's viewfinder to the television. This screen can then be positioned for comfortable viewing.

With many mirrorless cameras and digital SLRs there are a couple of tricks to facilitate focusing. The first is the command(s) for enlarging the image by 5x or 10x. This magnifies the centre of the field of view and allows inspection of the fine detail. Unfortunately, the entire field of view cannot be seen, and this makes it difficult to focus on moving specimens. An alternative command to this is 'peaking'. The peaking feature generates a colour fringe around the edges of in-focus borders. The size and colour of these fringes are set by the user. Because it shows the entire field of view, it is a feature useful for those who photograph moving subjects. The colour fringes are obvious and they can be easily seen on the small rear monitor of the camera. This feature is familiar to videographers, but not to most still photographers, and it may be absent on older models of digital SLR and mirrorless cameras.

We prefer not to use the camera's built-in rear monitor. The screen is too small, and for many camera models it will be pointed up towards the ceiling. A more convenient solution is to take the electronic output of the camera and direct it to an external screen. Cameras

designed to take HD or 4K videos usually have an HDMI ('high definition multi-medium interface') port, which can be cabled to an HD television. These enlarge the image from the camera to a size suitable for focusing. These monitors can range from 5in to 25in in diagonal screen size.

Alternatively, some digital SLRs and mirrorless cameras have a WiFi transceiver and can be set to send their image to the screen of a tablet computer. This will also provide an enlarged image; however, depending on the design of the software and hardware, the refresh rate on the tablet screen may be too slow. We had worked with only a limited number of camera models with this feature (Sony NEX 6, Sony a7, a7R, a7R II, a7 II, Panasonic GH4), and while we could use a tablet computer to focus the camera, we found it preferable to use a large screen monitor directly cabled to the camera.

Dedicated photomicrography cameras project the image from the camera to a computer monitor. As such, the image can be viewed, and it is enlarged sufficiently and with enough detail that it can be used for focusing. Most of these cameras can digitally increase the magnification to aid focusing. A major benefit of dedicated cameras is that they provide flexibility when viewing dim images, and one can bin pixels that will effectively brighten the image at the expense of resolution.

Camera Settings: White Balance

All colour cameras have a command for setting the white balance. This ensures a reproducible recording of colours and guarantees that neutral backgrounds do not exhibit a colour tint. This is necessary because photomicrographs are taken with different types of illuminators. LED lights emit a light similar to daylight, while quartz halogen bulbs tend to emit light with a warmer colour tint (Figs 44 and 45). Many cameras, as a default command, set themselves to 'automatic white balance' (AWB) so that they continuously adjust their output to ensure a neutral colour rendering under a variety of lighting conditions.

However, this convenient feature should not be used. AWB is a statistical sampling of the different colours within an image, and makes a guess at what

Fig. 44 Two images taken of a specimen illuminated with 5500K LED here the camera is set to 3200K, while in the next image

Fig. 45 The camera set to the proper WB of 5500K.

Fig. 46 The menu screen from a Sony camera for setting colour temperature value of the illuminant.

should be 'neutral'. For general photography it works well, and most casual photographers use this setting on their cameras. However, this setting is inconsistent, and if a scene has a predominance of one colour, the AWB will be fooled. When using AWB in a scene lit by tungsten lights, many cameras have trouble recording neutral colours and such scenes appear overly 'ruddy'. A far better strategy for consistent results is to set white balance manually.

This can be accomplished in one of two ways. The first is the traditional way of setting the camera's white balance to the colour temperature of the illuminant. Many manufacturers will rate their bulbs in degrees Kelvin, and this value can be set in many, if not all, digital SLR and mirrorless cameras (Fig. 46).

A better way to get a proper white balance is to directly calibrate the camera to a neutral area. On digital SLRs and mirrorless cameras there is a custom white balance setting. When activated, the camera is aimed at a white sheet of paper that is being illuminated by the photographic lights. Assuming the paper is truly white, it reflects the colour of the illuminator to the camera, and the camera can be triggered to calibrate its white balance from this reflected light. This customized value is recorded in the camera's memory and ensures this white balance value can be used repeatedly.

We found using this custom calibration to be easy to use on a microscope. First, set up your slide and view the specimen with Köhler illumination. You must make sure the field diaphragm is opened wide enough so that any colour fringes at its borders are outside the field of view. This is especially important when using a simple, chromatically uncorrected condenser. After setting up the slide for proper illumination, move the slide so the specimen is outside the camera's field of view. Next, execute the custom white balance command to set your camera's white balance directly against your illuminator. This ensures you will get a neutral colour rendering. Even if your optical system imparts a slight colour to the view, this will be removed by using this method of white balancing. If you use filters, such as a polarizer or neutral density filter, make sure they are present in the light path.

There are special conditions that require some judgement on setting white balance. One is when recording darkfield images. Since major portions of the field are a deep black, one has to decide how to alter the lighting to provide a brightfield effect for white balance determination. We accomplish this by using an objective whose NA is large enough to capture the direct light from the condenser. This will generate a brightfield view and white balance can be adjusted to this.

If you are working with fluorescent specimens, you will not be able to calibrate the camera for a custom white balance setting. This is of no consequence if you are using a black and white camera; however, if you are using a colour camera, we recommend setting the white balance to daylight. This provides a pleasing colour rendition. You should not use AWB for fluorescent images.

Camera Settings: Exposure

There are two ways to adjust exposure for photomicrography. The first is the gain on the sensor. The output from the sensor can be amplified so a faint sample appears brighter. With digital SLRs and mirrorless cameras this is accomplished by the ISO command. For these cameras, ISO is set once and the shutter speed is used to fine tune exposure. With most dedicated photomicrography cameras you will see a control on your computer screen for adjusting gain. The

units on this control are not ISO: it may simply be a slider which allows you to adjust the gain while studying the image. This control is set at the onset of the photography session. Again, exposure is adjusted by varying the shutter speed while taking pictures.

The rule of thumb for setting the gain is to use the default value established by the camera companies. In the case of digital SLRs and mirrorless cameras this will be an ISO between 100 and 200. Some cameras have an extended range and can be set to a lower value than their defined default; however, there is little advantage in doing so, as such settings reduce the dynamic range that the sensor can record. With dedicated cameras, the manufacturer has a default value that is specified in the camera manual. In addition, there is usually a command for restoring the camera to its default settings. So if you altered its gain, you can restore it by executing this command.

For some dedicated cameras it is possible to set two gain controls: one for the live preview screen, and the second for image capture. This handy feature is used for working under dim light conditions. You use the higher gain on the preview screen so that you can view faint subjects, as this feature enables you to compose and focus the specimen. When you take the picture, the camera uses the lower gain setting to take an image. Although this requires a longer exposure, it reduces the effects of noise. The longer exposure is calculated by the camera's software, and it gives the user the best of two worlds as he can use high gain for framing and focusing his picture, and then use a lower gain with long exposure to capture the image.

The disadvantage in increasing gain is the increased appearance of noise within the image (see Fig. 47). Fortunately, its appearance can be minimized by image post-processing. To do this, you should first save the files as RAW or sixteen-bit TIFF. Once saved, the files are worked on with image-processing programs such as Photoshop or DXO Pro. How well these programs reduce noise varies without causing a loss of fine detail.

One of the benefits of using the most recently designed cameras is the improvement in their sensor design and performance. Previously, with our older cameras, we did not use an ISO greater than 800. However, with many of the newer cameras, we can use an ISO of 3200. When working under low light conditions, it is important to maximize the light efficiency of the microscope. One obvious strategy is to use high numerical aperture objective lenses. One reason the 63x NA 1.4 and the 40x NA 1.30 objectives are popular in fluorescence microscopy is their high NA and relatively low magnification. Another way to ensure efficient light transfer to the camera is to use a photographic tube that sends 100 per cent of the light to the camera sensor. There are microscope heads that split the light between the phototube and the visual eyepieces. This design allows you to take pictures while looking at the specimen; however, it involves sacrificing some of the light for visual observation.

If you are able to take several exposures of the sample, you can reduce the effects of noise by averaging the pictures (see Fig. 48). The intensity variations caused by noise are random, and the appearance of noise can be reduced by taking several pictures and averaging the intensity of the pixels. This will make noise less obtrusive. You do not need to use a scientific image-processing program to do this, and a program such as Photoshop that supports layers can be used to reduce noise. This is done in the following way. Take four pictures of the same subject and load each picture in a layer. In the case of Photoshop, the bottom-most layer is called background and the other layers are numbered sequentially 1, 2, 3, and so on. Using Photoshop in this example, put a picture in the background layer. The second picture will be placed in Layer 1, the third picture in Layer 2, and the fourth picture in Layer 3. The opacity of the layer is adjusted as follows. The bottom-most, or background layer, is given an opacity of 100 per cent. Layer 1's opacity is set to 50 per cent, Layer 2's opacity is set to 33 per cent, and Layer 3 is given an opacity of 25 per cent. This process can be repeated if you recorded more than four images. To figure out the opacity for the layer, the following equation is used:

Layer opacity = 100x1/(# of layers + 1)

Remember the background or bottom-most layer is

Fig. 47 A photograph taken at ISO 102,400 exhibits noise. By taking six pictures and using Photoshop, the appearance of noise is reduced (see Fig. 48).

Fig. 48 Note the reduction of noise compared with Fig. 47.

THE IMPORTANCE OF BINNING AND GAIN IN FLUORESCENCE

When studying live samples with a fluorescence microscope, light is toxic. Organisms can be killed with the light source, and as a consequence pictures should be taken quickly, with minimum exposure of the organism to light. By using a high gain and binning in the live preview, it is possible to view, frame and focus the microscope under the lowest light conditions. When the time comes to take the picture, so as to reduce noise the picture can be captured at a lower gain without binning. Thus the organism's exposure to light is kept to a minimum. The binning and dual gain feature is highly desirable for low light work. Unfortunately, these are not standard features on all dedicated photomicrography cameras, and you need to check with the vendor to determine if these features are available on a specific mode of camera.

not numbered, and it will have an opacity of 100 per cent. When you merge the layers you will get a dramatic reduction in noise.

You can repeat this process with as many pictures as you wish to take; however, its effects become progressively less the greater the number of photographs. For most purposes you will not need to go beyond eight pictures. This imaging protocol does not reduce sharpness (Figs 47 and 48).

Photoshop has noise reduction commands that work on a single picture. These commands will take a group of pixels and compute the average intensity, and apply this value to the central pixel. This will reduce the appearance of noise, but at the sacrifice of edge definition. You can think of this as an averaging technique; however, the average is done spatially with the pixels occupying an area. In contrast, using multiple pictures for averaging is an example of temporal averaging. When this is performed, there is no loss of edge definition.

The control used to set exposure on the live preview is the shutter speed. Many of the digital SLRs and mirrorless cameras have an automated setting for accomplishing this, but we recommend you do it manually.

DIGITAL CONCEPTS 75

Figs. 49-51 These photographs show differing degrees of exposure Fig. 49 shows underexposure, Fig. 50 shows the camera recommended exposure, and Fig. 51 shows the image to be used for processing.

If the exposure is not optimum, which is frequently the case, the user needs to use an overexposure or underexposure setting to fine tune the exposure. Setting the shutter speed manually allows you to set the exposure directly, which is simpler and more straightforward. Dedicated photomicrography cameras provide the same options, and you can set the shutter speed manually from the computer, or you can allow the camera to determine exposure. Again, we prefer to use the manual exposure mode.

For evaluating exposure all cameras display a light intensity histogram. This is a plot of the light intensity (x ordinate) against the number of pixels with that intensity (y ordinate). The minimum light intensity value is on the left (0), the maximum light intensity value is on the right (255). In other words, the height of the graph shows the number of pixels at a given intensity. In a statistically perfect world, the histogram will be bell shaped (Figs 49, 50 and 51). In point of fact, the histogram may show multiple peaks and valleys across the x axis.

There are two guidelines in using the histogram. The shape of the histogram should show a taper at both its low (left side) and high (right side) ends. This is the usual situation, since microscope specimens tend to be of low contrast so that their maximum and

minimum light intensity values can be captured with one shot. A large number of pixels should not be seen 'piling up' at the minimum or maximum intensity values. A histogram with this shape indicates either under- or overexposure respectively. Figs 49, 50 and 51 show how varying the exposure can alter the appearance of the image and the shape of the histogram. These photographs were taken with a Sony a7R II camera and represent what the user sees when evaluating exposure through that camera's electronic viewfinder. The radiolarians photographed in this series are of low contrast, and their histogram has the approximate shape of a bell curve. With post processing, any of these images can be made to appear usable.

Since noise is more evident with low exposure, the two pictures that we choose to use would be either Fig. 50 or 51. If you do not wish to process the image, the exposure that generates the image in Fig. 50 will be used and the image saved as a JPEG. Such a picture would be attached to an email or posted to an online forum. However, if we wished to process the image and adjust its brightness and contrast, we would keep the image in Fig. 51.

Enhancing Fig. 51 results in the image in Fig. 52. Even though the original image appeared overly bright and unacceptable by visual inspection, its histogram indicates that all the light intensities of the specimen are being recorded. By reducing the brightness of the picture and adjusting its contrast, one can obtain a high contrast, sharp image. If the histogram intersects the right vertical axis and its shapes appear to 'pile up' along this border, then some of the photosites will have recorded the maximum light intensity they could and are fully saturated. A few pixels having this condition are not a problem, but if a large number of these pixels are in this condition and these photosites are adjacent to one another, then this area of the image will be a featureless bright mass.

Since the extent and location of fully saturated pixels is critical, many cameras come with a highlight warning feature. This may be a flashing between black and white on regions that are overexposed. The most advantageous use of this feature is found on the dedicated photomicrography cameras, where the overexposed pixels are highlighted with a colour (user defined). Because the image is displayed on a computer monitor, it is large enough to ascertain the extent of overexposed regions. The photographer can determine if it is an isolated pixel that is overexposed, or a clump of pixels. When a clump of photosites becomes overexposed they form a white area within the picture that does not display any detail.

This overexposure indicator on the dedicated camera is sufficiently precise that it can be used as an exposure meter for darkfield and fluorescent images. You adjust the exposure so that only a few widely separated pixels are saturated in the highlights, and this ensures that you capture the full details and objects that are bright against a black background.

These exposure tools work best with monochromatic light. However, if you are using a white light source and you intend to record in colour, you need to study an RGB histogram. This histogram displays the light intensities recorded in three colour channels: red, green and blue. Even if the single light intensity histogram looks properly balanced, you can find that the colours are out of balance but overall average each other out. Solid-state sensors are most sensitive to longer wavelength lights. When you use the single light histogram in a digital SLR or a mirrorless camera, you are measuring the overall luminosity of the picture. However, if you review the picture's three-colour channel histogram, you can see if any of the individual channels are under- or overexposed and make adjustments to avoid clipping any of the histograms. This is important if you play with the contrast and brightness of the picture. If one of the colour histograms is

Fig. 52 If the image shown in Fig. 51 is post processed, it reveals fine details. Theoretically, this image will exhibit the lowest levels of noise in the darkest regions as compared with Figs 49 and 50.

clipped, the ratio of green, blue and red light will change with brightness or contrast changes, and this can produce a shift in the colour tint.

Conclusion

We have discussed the basics of digital imaging and how they can be used to improve your photography when taking pictures.

To obtain the best quality pictures, make sure the magnification you use is appropriate for the objective's NA and the size of the camera's photosite. By using too little magnification, you can find that what limits the sharpness of your pictures is your camera, not your lens. There is a point when you can have too much magnification; however, this will not degrade your picture.

When saving your digital files, be sure to save them in either RAW or sixteen-bit TIF. This stores the maximum amount of data your camera records. These file formats record much more information than JPG. Also as important, and unlike JPG, these file formats will not show any loss of sharpness when repeatedly saved. As a side note, when saving your image files to your computer, create a folder and archive your data; then when you wish to alter or enhance a picture, copy the file to a new folder and work on the copied file. For a professional, having access to an unaltered picture file is a good practice.

When taking pictures use the ISO recommended by your camera manufacturer. For digital SLR and mirrorless cameras this will be approximately 100. There will be conditions when you need greater sensitivity for low light photography, and you can raise the ISO. Generally, most cameras are tolerant of being used at ISO 800. The higher ISOs start getting problematic. Many cameras can provide good images at ISO 1600, and a couple of models can provide good quality images up to ISO 6400. Cameras that work well at ISO 6400 use larger photosites to achieve a high signal-to-noise ratio and sacrifice pixel count. If you wish to work under low light conditions, a dedicated photomicrography camera with a small overall sensor size is the best choice. These cameras will have a C-mount.

Finally, take advantage of your camera controls for determining focus and exposure. This ensures that your sensor is recording as much detail as you see through the eyepieces of your microscope. The most precise control for determining the optimum focus is the magnification command. This is most foolproof when used with a large screen monitor. Some cameras have a peaking command, but we found this to be less precise. In terms of exposure, we rely on the live histogram, as this ensures the best exposure.

CHAPTER SIX

IMPROVING IMAGES

When taking a picture, the recorded image should be crisp and sharp. This is easy to obtain when working at low powers (200 power or lower), but when working at higher powers it becomes more difficult. It is also difficult when recording living organisms whose transparency reduces the contrast of the image they generate. This chapter describes how to maximize the sharpness of your images when working at these higher magnifications.

Commercially prepared permanent slides are often imperfect; furthermore, many of these do not use the correct coverglass thickness, and slides made by diagnostic laboratories may not even be overlaid with a coverglass. This frequently occurs when blood smears are stained and viewed. We will discuss how you can get around this problem. In addition, specimens vary in contrast. Colours may appear anaemic and washed out if the tissues are not properly stained. Also, if you work with older slides, their colours may have faded. However, there are strategies for bringing out their contrast. If you are interested in living organisms, you will find that many of them will be of low contrast – but again, there are strategies for increasing their contrast.

Cleaning the Lens and Sensors

There is no point in working with dirty lenses, as these will create low contrast images; besides, dirt on any lens will obscure the view and generate flare.

The first step in cleaning optics is to blow off any loose dust or particulate matter. We use a Giottos Rocket Blaster to remove small particles. This accessory can be purchased at photography stores or online. It is a plastic bulb which, when squeezed, forces air out of a nozzle. We use this on our regular photography lenses as well as on our microscope optics.

You can also use canned compressed air for this task; however, there is some danger in its use: because its gas is forced out at a high pressure, any particles on or within the nozzle can be ejected at high speed on to the lens. This can damage the coating of the lens, and possibly the lens itself, so as a precaution we aim the first blast of gas away from the lens before we attempt to remove any dust. Also, if you tilt the compressed air can too far, it will eject its propellant and this can be difficult to clean. If the dirt persists in adhering to the glass, we use a clean, oil-free nylon brush to wipe it off.

If that fails, or if there is a film on the lens, we try removing it with a moistened cotton swab, starting with distilled water applied to a ball of cotton on a wooden applicator. If the water does not remove the contaminant, we will use stronger solvents. Thus our next cleanser is ROR ('residual oil remover'), a detergent-based liquid that we buy online. We dampen the tip of the cotton applicator with ROR and gently wipe the lens surface, starting in the centre and using a circular motion moving outwards. Do not press down on the applicator: the cotton should just lightly brush the surface. Oils do not come off easily, so we will change applicators frequently. Never reuse an applicator.

If ROR does not work, we then use organic solvents. This is mandatory if you oiled a microscope objective or the top element of the condenser to either the cov-

erglass or the glass slide. In these cases don't bother using water- or detergent-based solvents: with oil, you wick off as much of it as possible and then clean the oiled components with a cotton applicator moistened with xylene. This should be done in a well ventilated room. Removing oil carefully is a tedious process, and is the reason why so few microscopists oil their condensers to the bottom of the slide. Using a condenser 'dry' means that the microscopist cannot record images at the full resolution of the oil immersion objective; however, the convenience of avoiding having to clean the condenser often justifies this practice.

As you will note, the cleaning process starts with the gentlest of procedures and then becomes more aggressive. You may have to use solvents to remove the offending material, though if these are liquid, apply them by moistening a cotton applicator: do not apply liquids directly to the lens. The best guideline for cleaning lenses is to do it as infrequently as possible: preventing them from getting dirty is easier and safer than cleaning them. So when the microscope is not in use, it should be covered, and for this, all you will need is a plastic bag. Eyepieces and objectives should always be in place on the microscope stand.

A camera's solid-state sensor has an optical window for the passage of light. Since the sensor's photosites are inaccessible, when we talk about 'sensor cleaning' we are actually describing the cleaning of that window – but for the sake of brevity, we will simply refer to cleaning this surface as 'sensor cleaning'. This transparent covering collects dust, and in most cases this can be blown away or removed by a nylon brush; however, unfortunately solvents may have to be used to remove those particles adhering to the surface. The first step is to determine if there is dirt on the sensor's surface, and this is accomplished by studying the live preview from the camera. If the camera is rotated over the microscope and the dirt does not change position on the monitor, the dirt is on the sensor. If the dirt moves while the camera is being rotated, then it is on the optics of the microscope or on the slide.

Once you discover the contaminant, one of two procedures will be used for cleaning the sensor. The first, and easiest, is cleaning the sensor of the dedicated photomicrography camera. First we blow off the surface of the sensor with a bulb, then brush it with a clean nylon brush. If this fails, we use a cotton applicator moistened with reagent grade ethanol. We swipe the region that has the dirt once, and then discard the cotton applicator. This is a straightforward procedure, and we have never damaged any of our cameras.

The difficult sensors to clean are the ones belonging to digital SLRs and mirrorless cameras. Most of these cameras have a command for cleaning that vibrates the sensor and its window to shake off loose dirt, and this should be the first step in cleaning these. If this does not work, then you will have to clean the optical substrate over the camera's sensor. We must point out here that these cleaning procedures may void the manufacturer's warranty, and many manufacturers recommend sending the camera to their service centres for sensor cleaning.

If you do decide to take the risk, we use the following strategy to clean the sensor of these cameras. First, for digital SLRs you have to reveal the sensor's window by using a command to raise the mirror and open the shutter curtains. For mirrorless cameras, the sensor is already exposed.

We use a bulb to blow air across the sensor's surface, and usually this removes most dirt. If this is unsuccessful, we will then use a clean nylon brush to wipe the surface. This brush must be absolutely clean: if there is any oil on its bristles, it will be transferred to the sensor's surface. If this does not solve the problem you will need to decide whether to send the camera to a service centre for cleaning, or attempt to clean the surface yourself.

The danger in cleaning digital SLR and mirrorless camera sensors yourself lies in the uncertainty of the safety of the cleaning products. Many photographers recommend using Pec*Pads and Eclipse cleaning solution. However, we noticed on the company's web site (http://www.photosol.com/about.html) a warning not to use their Eclipse solution on the sensors of the Sony a7 series cameras, and instead they urged the purchase of another of their cleaning products, Aeroclipse. In addition, the company does not recommend using Pec*Pads for sensor cleaning. These announce-

ments sound a note of caution regarding relying on online forums for recommendations on new technology.

With the above warnings in mind, we do clean our sensors ourselves, using the procedures we described with lens cleaning. We clean with a cotton applicator whose tip has been moistened with reagent grade ethanol. We do not clean the whole area of the sensor, but only that region where we identified the dust particle. We will swipe once with the moistened cotton tip applicator, and then discard the applicator. We then use our blower to puff away any loose dust. It is best to hold the camera so its opening is facing downwards; so when you blow off the dust it will fall outside the camera rather than moving to another location on the sensor. We then follow this up with the camera's command for cleaning the sensor. We have not damaged any of our cameras; however, our limited sample size does not guarantee that our procedures are harmless to the sensor, and if you decide to use them to clean your sensors, remember there is always a risk.

We should mention that sensor cleaning is a rare event in our laboratory. Considering the potential danger of damaging the camera, we prefer to rely on preventative measures to keep our equipment clean. So when our cameras are not mounted on a microscope, they have either a lens or a body cap attached to prevent the ingress of dust.

Coverglass Thickness and Contrast

A thin coverglass is used to view most material under a microscope. If the coverglass is too thick or thin, the image will be blurred and lack contrast. Although we described coverglasses in Chapter 2, we will expand the subject here with the aim of providing ways to improve the photograph. Unfortunately, some of the solutions may require buying a new objective lens.

One preparation technique that results in blurry photographs is the failure to apply any coverglass to the specimen. This is practised in some laboratories that make smear preparations, for example when blood is drawn across a slide's surface so that it makes a single layer of cells. Typically these preparations are stained, dried, and viewed using an oil immersion objective without a coverglass. If a 40x dry objective is used instead, the absence of a coverglass blurs the image and renders it unusable for publication. To improve the image when working with a high dry objective, simply slide a coverglass over the smear: even though it is free floating, the coverglass will not fall off the slide when it is on a horizontal stage. This example serves to illustrate another point.

Oil immersion objectives are insensitive to coverglass thickness if the mounting medium is Permount or a reagent whose optical property is the same as glass. Adding a drop of oil over such a preparation creates an optically homogenous environment. There are no optical changes as light passes from the specimen to the front lens of the objective. Thus, a specimen mounted in Permount and overlaid with a coverglass is optically equivalent to a naked specimen dipped in oil and viewed with an oil immersion lens. Consequently, if you suspect the coverglass is too thick or too thin, you can improve the image by using an oil immersion lens instead of a dry lens.

The disadvantage of using an oil immersion lens is the inconvenience of having to remove the oil and clean the slide when you want to use your dry objectives. This can slow down your progress when recording a stained slide at various magnifications. To speed up our work, we use a microscope that has only oil immersion objectives: a 10x NA 0.45, 25x NA 0.75, 50x NA 1.0, and a 63x NA 1.30. Once oil is applied to the slide, any objective can be used. It has the advantage that it automatically compensates for variations of incorrect coverglass thickness.

The lens that is most prone to showing reduced contrast with an incorrect coverglass thickness is the dry 40x NA 0.95 objective. Images from this objective will show a loss of contrast if the coverglass thickness is off by 0.01mm. Fortunately, most objectives of this type will have a correction collar.

Below is a step-by-step description for setting the collar:

Step 1: Adjust the microscope for Köhler illumination.

Step 2: Rotate the high power dry objective lens (eg 40x or 60x dry objective).

Step 3: Set the condenser iris so that it fills three-quarters of the aperture of the objective.

Step 4: Turn the correction collar so that its index mark is opposite 0.17mm, and focus on a fine delicate structure. Carefully judge the sharpness and contrast of this image.

Step 5: Turn the correction collar so that its index mark is opposite 0.18mm, and return the focus to the fine structure you observed in Step 4. The loss of focus when turning the correction collar is normal for this type of lens.

Step 6: Evaluate the image and determine if the details seem crisper and in higher contrast. If this is the case, then continue turning the correction collar in increasing 0.01mm increments until the image does not improve.

Step 7: If the image does not improve at Step 6, you must turn the correction collar in the opposite direction by 0.01mm increments.

Step 8: The setting that produces the image of best sharpness is the one you will use.

Executing the above series of steps is tedious and takes practice. If you have trouble seeing the changes in sharpness, consider raising the power of the eyepiece. On occasion we will use a 20x eyepiece; however, with experience, the procedure can be done with a 10x eyepiece. Some investigators may feel it is easier simply to use a 40x oil immersion lens. In point of fact, with our working microscope, we have two 40x objectives: a dry objective with an NA of 0.85, and an oil immersion objective with an NA of 1.0. An advantage of using an oil immersion lens of comparable NA is that it usually has a greater working distance (about 50 per cent more). This is helpful when working with a permanent slide, which has a surplus of mounting medium.

Using an oil immersion objective is not a universal solution; for example, it is of limited value when viewing live protists in a temporary mount. When changing focus, the oil's viscosity tends to raise and lower the coverglass, and this can displace the specimen. To avoid this, we use a water immersion objective. There are two versions of these objective lenses: the first is the dipping lens which is used without a coverglass – as the name implies, this lens is to be dipped into water. Such lenses are characterized by a long working distance: an objective for this work is the Zeiss 40x 0.75 NA lens. This lens has a 2mm working distance, which made it popular among neuroscientists. The working distance is long enough to allow a researcher to monitor the insertion of microelectrodes into a neuron. This type of objective usually does not have a correction collar. You can sometimes purchase this lens on the used market.

The second type of water immersion lens is one designed to work through a coverglass. These lenses are designed for studying living cells grown in a culture chamber, and with many, the cells are grown on the coverglass. The correction collar is used to correct for variations in this glass thickness. These objectives can have an NA as large as 1.25.

Stained Samples

Although we view mostly with coloured samples, it is often advantageous to record these subjects in black and white with the aid of colour filters. However, it is easy to forget that the simple interposition of such filters in the illuminator can enhance or subdue contrast. For example, in many histological slides, two stains are used so that the nuclei of cells are stained blue while their cytoplasm is stained pink. The separation of these two structures can be made more evident by using a red filter in the light path and rendering the image in black and white. The print will display a darker nuclei and a lighter cytoplasm, which provides a clearer distinction between these two

Figs. 53 and 54 Two pictures of a red stained tissue. Contrast is enhanced in the black and white photograph by using a blue filter.

structures. Coloured filters can accentuate contrast if only a single dye is used.

In electron microscope laboratories, tissues are routinely stained with toluidine blue, a dye that colours tissues in various shades of blue. If a section is too thin, it may not take up enough dye to provide sufficient contrast. This deficiency can be easily remedied by photographing the specimen in black and white and using a red filter to impart greater contrast. Similarly, this advantage can be illustrated with a photograph of an Amphioxus embryo stained to render its nuclei red. In the colour photograph there is little contrast (see Fig. 53); however, by interposing a blue filter in the light path and recording in black and white, the resultant print exhibits greater details than the coloured print (see Fig. 54).

Unstained Samples

Occasionally the microscope is used to study living organisms such as tissue culture cells, free-living protozoa, or small animals that live in pond or sea water. Many of these organisms are transparent with little intrinsic contrast, so the skilled microscopist must devise a method of illumination to increase the definition of the organisms' structures. The most immediate control is the condenser iris diaphragm. Typically, the condenser provides a cone of light that fills the objective lens. This works well with a stained sample that is chemically dyed to display a wide range of densities. However, when done with a transparent structure, the image may lose so much contrast as to disappear from view (Fig. 55). To increase contrast, the condenser iris is stopped down while looking through the microscope. Contrast will increase, and image quality is evaluated while closing the diaphragm (Fig. 56).

However, there are trade-offs to closing down the condenser iris diaphragm. While it increases the contrast at the cell's edges, it also causes a loss of resolution (Fig. 57). The degree to which the condenser needs to be closed is determined by practice. Some

Epithelial cell that changes in appearance with the aperture wide open.

Fig. 55 with the aperture fully open.

Fig. 56 with the aperture half open.

Fig. 57 with the aperture closed to minimum value.

protozoa require very little closure, while a monolayer of flattened cells requires a great deal of closure. With experimentation, you will learn what works well under different circumstances. Also keep in mind that post processing the image can be an aid in obtaining the highest resolution with a wide open condenser aperture. To provide higher contrast and resolution when viewing transparent specimens, the microscopist may use lighting techniques that require specialized accessories. These techniques are described in the following section.

Darkfield Illumination

As the name implies, this type of lighting produces a black background with a glowing subject. This is achieved by using a condenser whose light does not enter the objective lens directly: instead it generates a hollow cone of light which rises from its top lens and whose apex is at the plane of the specimen. The cone has a large diameter so that it misses the objective lens (Fig. 58). Instead, light from the cone's apex is scattered by the specimen and is collected by the microscope's objective.

Fig. 58 A translucent block shows the light arising from a darkfield condenser. Note the V-shaped shadow.

Fig. 59 A diatom arrangement photographed with darkfield lighting.

Darkfield illumination is obtained by using a modified condenser. To understand how this works, first consider setting up a condenser with Köhler illumination. It receives a cylinder of light, collects it, and then projects a solid cone of light to the objective lens. Normally the entire cone of light enters the lens. To achieve darkfield, you modify the incoming light by blocking the light from the centre of the condenser so a hollow cone of light is projected on to the specimen. If you place an objective lens in this hollow cone, it does not receive direct light from the illuminator. If there is no specimen, then the view through the microscope is dark because there is no direct light entering the microscope. If there is a specimen, it scatters some of the light and appears to glow against a black background (Fig. 59).

Darkfield illumination is excellent for studying small particles that appear as glowing dots against a black field. Living bacteria are easily visualized with this technique, and protozoa and small free-living animals in fresh- or seawater also lend themselves to this type of illumination. With the right equipment it is possible to detect objects smaller than the limit of resolution of

the microscope: for example microtubules, a protein polymer only 25nm in diameter, can be seen with this technique. This is remarkable in that the lenses used to detect this small strand have a limit of resolution of 250nm.

Darkfield Condensers

The simplest and most inexpensive implementation of darkfield illumination is modifying the condenser with an opaque stop to generate a hollow cylinder of light. We have used a small coin, about 20mm in diameter, to generate darkfield illumination for 10x and 40x objectives. This technique will show pond water organisms, free cells and bacteria. To apply this technique, adjust the condenser for Köhler illumination, attach a coin (approximately 20mm in diameter) securely to the bottom of the condenser with clear tape, and open the condenser iris to its maximum. Make sure the coin is centred in the condenser opening, and that the tape does not touch the lens. This is easy because the bottom lens is recessed so that the coin and tape are well separated from the glass. You may need to play with the height of the condenser to create a true darkfield.

Slightly raising or lowering the condenser may result in the sample appearing brighter and the background darker. Student microscopes are often equipped with simple condensers that are uncorrected for spherical aberration: in other words, light rays passing through the periphery of the lens are not brought to the same focus as light passing through its centre. Slightly raising or lowering these condensers can compensate for this defect.

Many older microscope stands can be easily modified for darkfield illumination. These scopes often have a swing-out holder for coloured filters, and the holder allows the removal and replacement of different colour discs. This can be a handy feature if you have clear glass discs that will fit in the holder. You can laminate celluloid filters on to the disc and make your own colour filters, or you can take a coin and glue it to a clear disc to make a central stop for darkfield illumination. If you do this, you can quickly switch from bright-field to darkfield illumination by swinging the clear filter with the stop in or out of the optical path. We found glass watch crystals useful for making the stop; they come in a variety of sizes, and we have used these as glass substrates for our darkfield stops.

Dedicated Darkfield Condensers

The main disadvantage with using an opaque stop on a standard condenser for darkfield work is that the background may not be a deep black. Dust and dirt on the top surface of the condenser lens can scatter light and cause glare. For studies that require the highest SNR ('signal-to-noise ratio') there are dedicated condensers that provide the darkest field. These condensers use a reflector as part of their optical design.

There are two types of dedicated darkfield condenser: a dry condenser designed to be used with lenses with an NA of 0.8 or lower, and an oil immersion condenser designed for lenses with an NA of between 0.8 and 1.0. In terms of resolution, dry condensers can be used with objectives that resolve structures separated by 0.7 microns, while oil immersion condensers can be used with objectives that resolve structures separated by 0.3 microns (assuming that one uses light of 550nm and an objective with an NA of 1.0).

The increased resolving power of oil immersion condensers is attained at the expense of convenience and field of view. As we have pointed out previously, using oil to join the top lens of the condenser to the slide is messy. In some cases, the aggravation is justified by its superior performance, though you may have to buy an additional objective for this work. Since most oil objectives have an NA of 1.2 or greater, they are unsuitable when used with an oil immersion darkfield condenser. For this type of work the objective should have an NA of 1.0, and an example of this lens is the 40x NA 1.0 oil immersion objective. This lens provides a bright, high contrast image.

Alternatively, there are objectives with an NA of 1.2 or larger that can be stopped down to an NA of 1.0 with the aid of a built-in iris diaphragm. There are 100x oil immersion objectives with this feature; however, the image from the objective will be considerably dim-

IMPROVING IMAGES 85

mer than that from a 40x NA 1.0 objective. You can use this type of condenser with lower power dry objectives; however, this is not done routinely. As noted earlier, working with oil is a messy and inconvenient task, and most will reserve using this type of condenser for the most critical tasks.

A more useful condenser for general photomicrography is the dry one for working with objectives with an NA of 0.8 or lower. This generates an extremely darkfield effect, provides a wide field of view, and is very convenient to use. It is characterized by having its top lens element recessed, and shaped as a concavity, so any dust on its surface is displaced away from the bottom of the slide. This differs from the standard condenser modified for darkfield work, which has a flat top lens only a couple of millimeters beneath the slide. Any dirt on this lens will create glare.

Fluorescence Microscopy

Although the rationale for using fluorescence differs from darkfield microscopy, both techniques record a

Fig. 60

Fig. 61

Fig. 62

Fig. 63

A cultured cell stained with three fluorescent dyes. The nuclei are blue (Fig. 60), the mitochondria are red (Fig. 61), and the stress fibres (Fig. 62) are green. Fig. 63 shows a three-colour merge in the cell.

bright object against a black background. In terms of imaging theory, fluorescence is also similar to darkfield in that the illuminating light is not used for direct viewing. Instead, structures are induced to fluorescence – that is, they glow when struck by light of a specific wavelength. Their emitted light is detected by the eye and recorded by the camera. Typically, a dye is used to generate fluorescence (see Figs 60, 61, 62 and 63).

Fluorescence microscopy requires a special illuminator and filter. In modern microscopes, the condenser beneath the stage is not used. Instead, the objective lens concentrates light on to the specimen. The light originates from a special illuminator mounted behind the microscope and aimed towards a semi-silvered mirror just above the objective. An exciter filter selects the wavelength to be used for illumination. This mirror is designed to reflect this light and transmit light of another, longer wavelength (fluorescent light). A barrier filter ensures that only the fluorescent light passes to the eyepiece or the camera. Any scattered light from the illuminator that hits the specimen is blocked by this filter.

Since the illuminator's light is not imaged by the eye or sensor, the view is black. The only light that is imaged is that which arises from the fluorescent specimen. Because of this, the sample appears to glow against a black background, and photographing it has the same requirements as an image seen by darkfield photography.

Although the theory of fluorescence illumination differs from darkfield lighting, both techniques generate a bright object against a black background. Fluorescence requires a specimen which, when excited by light, will emit light of a longer wavelength. It is a highly specific technique for identifying chemicals, since most of the sample will not fluoresce. In the laboratory, fluorescent dyes are used for imaging. They are bound to molecules which bind to specific proteins or complex sugar groups. However, fluorescence is not a technique just for the laboratory: the hobbyist can explore the natural world, since some of its subjects will fluoresce when subjected to light. An example of one is chlorophyll. Such objects are described as being auto-fluorescent.

Difficulties Photographing Fluorescent Specimens

Fluorescent specimens are dim, and an exposure of several seconds may be needed to record them. Unlike most other techniques, it is impossible to shorten the exposure by using a more intense light since the mercury arc illuminator is the brightest illuminator commonly available to the microscopist. When exposed to continuous lighting, many fluorochromes will lose their fluorescence ability and fade. This difficulty is compounded by the delicacy of the subjects. If it is a live specimen, the excitation light can kill or damage it. Shorter exposure times limit the deleterious effects of illumination.

Accurately composing and focusing such dim subjects is a challenge. The optical viewfinder of the digital SLR cannot be used, so instead, the live view feature of the digital SLR or the mirrorless camera is used. For these cameras, their white balance should be set to daylight, and you will need to set the camera's ISO to a high value of 1600 or greater. You will have to judge how high an ISO you wish to use: a low ISO means a longer exposure duration and the sample may fade; a higher ISO will keep the exposure time short, but there will be an increase in noise. When photographing with these cameras you should shoot in the camera's RAW format. This will allow maximum flexibility in reducing noise using noise reduction software in post processing. Although digital SLR and mirrorless cameras will work with your microscope, they are not the most suitable for fluorescence work.

The most suitable camera for fluorescence microscopy is the dedicated camera with a small sensor. This allows you to use a lower magnification relay lens, which shortens exposure time. Also, these cameras can be purchased as black and white recorders. The removal of the Bayer mask – the red, green or blue filters placed over the sensor for colour imaging – increases the light available for image capture. This in turn increases the camera's sensitivity, an advantage when imaging a faint sample. Many dedicated cameras can be purchased with an electronic cooler (Peltier device), which reduces the deleterious effects of thermal noise. These effects become evident when

exposures run for several seconds. Moreover, the binning and dual gain controls ensure accurate exposures by allowing you to preview the results of your settings in real time. As a result, you won't need trial exposures to ensure the successful recording of a specimen.

Colour Imaging in Fluorescence

When looking through a fluorescent microscope, the microscopist sees a coloured image against a black background. Typically one hue predominates – red, green, or blue – and it would seem logical to use a colour camera to record the scene. However, this intuitively obvious strategy is unwarranted and may be counterproductive. The usual goal in fluorescence microscopy is to visualize a specific dye that glows with a characteristic colour. The image is actually monochromatic. A colour camera equipped with the Bayer mask does not capture such an image efficiently because the filters overlying the sensor will absorb light and reduce its sensitivity. To capture a fluorescent image, a black and white (monochrome) camera is more suitable because it is more sensitive than a colour camera and has the additional benefit of higher resolution.

As mentioned earlier, images from a black and white camera can be used to generate colour pictures. This is based on colouring the images digitally. For an image with a single dye, the photograph may be coloured green to mimic the emission spectrum of fluorescein. However, the value of doing this for one dye is limited, and it provides no more information than showing it as black and white. However, when you have a specimen stained with three dyes, it is possible to show their relative positions by pseudo-colouring them red, green and blue (see Figs 60, 61, 62 and 63).

This generates a full colour image. Where the dyes are separated spatially, they exhibit their primary colours; when two dyes occupy the same region, they form a secondary colour. For example, if a green dye and red dye occupy one area, that area appears yellow in the pseudo-coloured image. Such photographs do not represent a single colour exposure, but rather the combination of two or three black-and-white images. Each exposure is for one dye, and that dye is assigned a colour in the final print. Customarily, colours are assigned to mimic the hue that the dye is fluorescing; however, this is unnecessary.

Photographic Settings and Strategies

Fluorescent imaging requires the effective capture of every photon emitted by the subject. Considering the delicate nature of most biological structures, the microscopist should adopt strategies for reducing exposure.

Keep in mind that for this type of work it is preferable to work with a smaller sensor camera than with a larger one. In other words, for an interchangeable lens camera, the Four Thirds sensor cameras are preferred over a full frame camera. The ideal camera is a dedicated photomicrography camera with a small overall sensor size. Generally these will have a limited pixel count of only two or three megapixels. In terms of exposure, the live histogram will not be useful: the predominance of a black field will give a skewed distribution of light intensities. You will have to use a different strategy for determining exposure. We use a spot meter and measure the fluorescent structure, and we bias it to overexposure. Generally, if one uses the brightest value to set exposure, its brightness will be recorded as being a 'middle' intensity value. By providing more exposure to this area, it ensures it will be recorded as a high intensity area.

The second thing to realize is that the NA of the objective is important for light gathering. A larger NA for a given magnification will produce a brighter image. With epifluorescent illumination, the objective also serves as a condenser, and its wider numerical aperture will focus more light on to the specimen. As a consequence, a 25x lens with an NA of 0.65 is to be preferred over one with an NA of 0.45. For high NA oil immersion lenses, the 60x and 40x NA 1.3–1.4 are popular in laboratories working with fluorescent microscopy.

When purchasing lenses for this type of work, be

very cautious of buying lenses on the used market, as some of the older lenses will not transmit the lower wavelengths effectively. We attempted to use a Zeiss Panapochromat 63x NA 1.4 and found that our sample would not transmit violet light. When testing more recent versions of this lens, we did not observe this problem. Also, although one might expect apochromatic lenses to be the best buy because of their large NA, this is not always the case. For fluorescence work, a simpler lens design with fewer lens elements may be preferable. This is because less light is scattered when fewer lens elements are used. Such lenses provide a higher contrast image.

Also be cautious when buying used fluorescent microscopes as the filters and dichromatic mirrors will degrade with time. This is exacerbated under poor storage conditions. We have found that fluorescent filters used in a marine biology laboratory developed a coating that prevented light from passing through them. More frequently, we found used filters to be delaminated. Most modern fluorescent filters are not simply solid glass elements that only pass a certain wavelength of light, but consist of multiple layers of coating which isolate wavelengths of light by interference. Such filters can delaminate, and a visual inspection of the filter will reveal, in some cases, a series of concentric rings.

One thing that may be of interest to the hobbyist is that many of the filters used in biological research are not the best for looking at auto-fluorescent samples. The filters are designed to be eliminative, and for localizing dyes with specific absorption and emission properties. Wavelengths which are not desired are rejected. For natural fluorescence, a filter set for collecting a wide array of wavelengths is desirable. You should be on the lookout for a filter set-up that excites with lower wavelengths, such as violet, but which will pass all wavelengths greater than the excitation light. These barrier filter types are termed 'long pass' filters. As the name implies, they are designed to pass wavelengths longer than a specified wavelength. In contrast, most fluorescent microscopes use band pass filters: that is, filters that only pass a defined wavelength. These filters will reject wavelengths that are both shorter and longer than the one they are designed to collect.

Contrast by Phase Differences

Many biological structures have little intrinsic contrast. They are clear and difficult to see against a bright background. Staining the sample with dyes is one method of increasing the specimen's ability to absorb light; however, this is deleterious to living organisms since the stains are toxic. Safer ways to create contrast, sometimes referred to as optical staining, require special optical accessories. Light is slowed by the transparent structures of cells and thrown out of phase in comparison to the light that traverses outside them. These phase changes are invisible to the naked eye. However, by altering the microscope optics, it is possible to visualize their effects. This is accomplished by two imaging techniques: phase contrast and differential interference contrast. Both require the acquisition of a new condenser, and phase contrast also requires special objectives. The main disadvantage of these techniques is the increase in expense over a standard microscope. However, for viewing live cells or studying free-living animals, they generate high contrast while maintaining resolution. Once the microscope is modified, it can still be used for traditional brightfield observation of stained samples.

Phase Contrast

Phase contrast, developed by Frits Zernike, is a technique providing high-contrast images of cells and living organisms. If a microscope has interchangeable condensers, it can almost certainly be adapted to phase contrast.

The objectives have a special phase ring, and the condenser is designed to project a cone of light to pass through that plate. You will have to use objectives with the phase rings, but fortunately, these objectives are also usable for brightfield work. When used for brightfield, their image contrast may be less than non-phase objectives. This deleterious effect varies from objective to objective. We can clearly see it when using a Zeiss 40x 0.75 Neofluar phase objective, but we cannot see a degradation in brightfield when using a Zeiss 25x NA 0.60 phase Neofluar

objective.

The phase contrast condenser is usually designed to work with a variety of objectives, so it is equipped with several annuli for a range of objectives. Generally, these annuli are mounted in a disc for rotating the proper aperture into the light path. There is an open aperture for use with the iris diaphragm for brightfield work.

In phase contrast, the cone of light is collected by the objective, so the field appears light whether a specimen is present or absent. The purpose of this design is to separate the direct light from the illuminator and the scattered light generated by the specimen. This is in contrast to darkfield illumination, where the separation is absolute and no direct light enters the objective; only diffracted or scattered light is used in image formation.

In contrast to the darkfield condenser, the phase condenser only partially segregates the direct light from the scattered light. The direct light is spatially restricted to a ring that can be seen when you remove the eyepiece and peer down the tube. The area surrounding this ring collects the scattered light. The segregation between scattered and direct light is not complete since the annular region where direct light passes must also contain some of the scattered light. The rationale for separating the light is to permit the optical designer to alter the scattered light as well as the direct light. This is based on Abbe's diffraction theory of image formation and the wave characteristics of light.

Abbe postulated that image formation requires the interaction of light rays between direct and scattered light. This is shown by viewing a grating with the microscope and using a narrow parallel ray of light. By pulling out the eyepiece, you see a bright spot (the direct light) and the first and second order diffraction spots. The latter result from wave interaction between direct and scattered light. With wave theory, you have constructive interference when two waves are in phase – that is, when the peaks and troughs coincide. The height of the peaks and troughs adds up so that the peaks are higher and the troughs are deeper. This results in constructive interference and the spots appear bright. Conversely, if the waves are one-half wavelength out of phase, a trough coincides with the

Fig. 64

Fig. 65

Annulus of light centred in (Fig. 64), and off centred (Fig. 65) in the phase ring.

90 IMPROVING IMAGES

Fig. 66

Fig. 67

Cheek epithelial cell illuminated by brightfield lighting (Fig. 66) and phase contrast (Fig. 67).

peak of another wave and the effects cancel out. The reduction in peaks and troughs results in diminished light intensity, an example of destructive interference.

When light passes through a transparent specimen, the scattered light is only out of phase by one-quarter wavelength. The image has no contrast. If, however, you take this scattered light and increase its phase offset to one-half wavelength, you can generate a high contrast image.

Altering the phase difference between direct and scattered light is the basis of phase contrast. To accomplish this end, the phase objective has a plate with an annulus matched to the ring of light you see when the eyepiece is removed (Figs 64 and 65). The plate is a disc with either a groove or ridge inscribed in the annulus. Depending on the depth of the groove, you can alter the phase relationship between the direct light and the scattered light. The thickness of the groove imparts a phase shift to the direct light, which results in a phase image. In negative phase contrast, the subject appears darker than the background when its index of refraction is higher than that of the medium. When the same subject appears darker, this is an example of positive phase contrast.

The phase objective annulus has a coating that serves as a neutral density filter. It reduces the intensity of the direct light passing through the specimen and prevents it from overwhelming the surrounding scattered light. Correct matching of the objective and the condenser annulus is critical for generating good contrast with this equipment. Theoretically, you can pull out the eyepiece and align the phase annulus to the objective's phase plate with special centring screws. However, the rings may appear too small to centre accurately. To magnify this image, a phase centring telescope is used in place of the eyepiece to enlarge the view of the back of the objective lens. With this tool, you can easily centre the phase annulus to the ring in the objective. Once the rings are aligned, the telescope is removed and replaced with the eyepiece. To image with phase contrast, you need the following:
* Objectives modified with phase plates
* Phase contrast condenser
* Phase centring telescope

The increased contrast obtained by a phase contrast microscope is striking. Figs 66 and 67 show an epithelial cell photographed in brightfield and phase contrast. The improvement in the image is dramatic.

IMPROVING IMAGES 91

Fig. 68

Fig. 69

Epithelial cell illuminated with positive phase contrast (Fig. 68) and negative phase contrast (Fig. 69).

When buying a microscope, you can add phase contrast accessories for a modest investment. Phase objectives can be used for regular brightfield and darkfield work, and their cost is only slightly higher than non-phase objectives. The major expense is the phase contrast condenser. Since the phase rings are matched to different objectives, the condenser typically has a large disc that contains several annuli. For example, the older Zeiss Oberkochen phase contrast system has three different annuli: the smallest is for the 10x objective, the next largest is for objectives with an NA between 0.4 and 0.8 (generally 16x, 25x and 40x objectives), and the third is for objectives with an NA greater than 0.9 (40x, 63x and 100x oil immersion objectives). The smallest annulus is unnecessary for investigators who dispense with the 10x objective and use the 16x for phase contrast work.

Phase contrast images have an appearance that is easily interpreted by those who are used to looking at stained samples. Objects display variations in intensity and increased contrast. However, artefacts can result from a phase image, the most common being the phase halo. In positive phase images, this will appear as a peripheral bright region that obscures fine details at the border of an object. In negative phase images, this halo appears dark. You can adjust contrast by altering the index of refraction of the medium. If you have a specimen that can be mounted in different mediums, the contrast can be enhanced or reduced depending on the medium. One way to increase the index of refraction of a medium is to have albumen mixed into water.

Another way to control contrast is by selecting objectives with special phase plates. This was a popular option with older microscope designs; American Optical microscopes had an extensive series of these objectives. Today, the selection of phase plates for adjusting contrast is much more limited. Typically, modern microscopes are equipped with phase objectives, so when a cell is observed, it appears darker than the surrounding medium (Fig. 68). You can purchase a phase contrast objective that reverses the contrast so the cell appears brighter than the medium (Fig. 69). Positive contrast provides a view that is more typical and easier to interpret. Negative contrast is more suited for counting where individual cells stand out and are readily identified.

92 | IMPROVING IMAGES

Differential Interference Contrast (DIC) Microscopy

Differential interference contrast (DIC) microscopy uses phase differences to generate contrast. It is a more recent development than phase contrast; however, buying it on the used market is risky as the DIC prisms can delaminate and this ruins them for this type of work. The components for this type of imaging are expensive. One has to obtain a polarizer, an analyzer and a set of Wollaston prisms for different objectives. Finding proper DIC accessories for older, discontinued microscopes is a challenge. If you have the funds, it is much easier to buy DIC from one of the four major microscope manufacturers (Leica, Zeiss, Nikon and Olympus) where the top research-grade microscopes can be equipped with DIC optics for imaging live cells. Microscopes currently in production will have a wider range of objectives and prisms for DIC imaging than components that can be found for the older fixed tube length microscope.

There is a tendency among new microscope users to view DIC as a replacement for phase contrast, but this is not the case. Phase contrast and DIC are complementary illumination techniques; depending on the specimen, one may be more appropriate than the other for displaying fine details (Figs 70 and 71).

The DIC system generates image contrast with a polarized light, enabling the Wollaston prism to split the light into two beams; the beams are slightly displaced one from another (less than the resolution limit of the objective) so you don't see a double image. The two beams illuminate the specimen and are affected by its structures. They are recombined by a second Wollaston prism to generate contrast. The prism can usually be shifted laterally to change the contrast of the observed image. Generally, the highest-contrast image appears in shades of grey; however, by using a more extreme setting, you can generate a beautifully coloured image.

Epithelial cell illuminated with phase contrast (Fig. 70) and DIC (Fig. 71).

Fig. 70

Fig. 71

Phase Contrast versus DIC Imaging

These two imaging modalities generate dramatically different results. Perhaps the easiest way to appreciate this is to compare a micrograph of a subject photographed with each. By studying the smaller granules within the cells, the predominant difference between phase contrast and DIC is revealed. In phase contrast, the particles appear dark surrounded by a bright halo. In contrast, there is no halo with DIC; instead, the image has sharp borders with a three-dimensional appearance. One side appears light while the opposite side is dark, and this gives a heightened sense of contrast and makes small objects stand out. A comparison of brightfield with these two techniques shows that both phase contrast and DIC generate a much higher-contrast view with more detail. In the case of phase contrast, the nucleus is dark and elliptical, and its periphery has a bright border. With DIC illumination, the nucleus does not appear as a darkened ellipsoid; rather, it has an artificial three-dimensional appearance. At the periphery, there is a bright edge on one side and a darkened shadow on the opposite side. In terms of the composition of the nucleus, there is no difference between one side and the other.

Determining which method of illumination to use depends on several factors. To obtain the highest degree of resolution possible, the preferred technique is DIC with an oil immersion condenser. DIC is extremely sensitive for observing fine structures. It can provide sufficient contrast to detect objects smaller than the resolving power of the microscope. DIC has been used to visualize single microtubules – protein polymers that are 0.025 microns in width, or almost one-tenth the limiting resolution of the microscope. Moreover, DIC is amenable to computer-generated contrast enhancement. This provides even more sensitivity in detecting minute objects.

In many laboratories, DIC is viewed as the standard means of studying living cells. Its disadvantage is the expense. It is necessary to purchase a specialized condenser which is fitted with a Wollaston prism dedicated for a specific objective lens. Above the objective lens there is another Wollaston prism. Some manufacturers require only one prism for all objectives, while other companies require the purchase of individual prisms for each objective.

Phase contrast does not have the fine resolving power of DIC. Nonetheless, it provides high-contrast images that enable the study of cell organelles. The major problem with phase contrast is its generation of halos surrounding some structures, and this artefact can obscure fine details. For work using plastic culture dishes, the phase contrast system will generate a high-contrast image while DIC will fail. This is because the plastic depolarizes light, and contrast cannot be generated without polarized light.

Virtually any digital camera can easily record images produced by phase contrast and DIC illumination. Unlike darkfield or fluorescence, the background lighting does not overwhelm the light meter when taking phase contrast photographs, so automatic exposure can easily record the images. The major concern for DIC images is that increasing contrast with their Wollaston prism may increase contrast too much and cause the bright borders to become overexposed. Generally, when adjusting the contrast in DIC, the value used for visual observation is not the one to be used for photography. Contrast adjustment should be performed while studying the live preview from the camera.

Conclusion

Getting the highest quality pictures requires a meticulous attention to details. Dirt and dust on the optics will create shadows over the image, and if dirt is present in sufficient quantity, it will create flare and reduce contrast. The best way of keeping your optics clean is preventative maintenance. Always keep the microscope covered when it is not in use. Similarly, always keep the eyepiece tubes and objective openings covered. Normally, these openings will be closed by the eyepieces and the objective lens. Even with the best care, cleaning will be required eventually. This should

be done delicately with the gentlest procedures being used first.

In addition, it is important to keep your camera's sensor clean. If the camera has a cleaning mode for its sensor, this should be activated regularly. When cleaning the lens or sensor, use a bulb to blow air over the optical surface. If this is insufficient, then use an oil-free brush and sweep the dust off. Only as a last resort should one clean with the aid of liquids. Cleaning the camera sensor should be an infrequent event.

Surprisingly minor things can degrade the quality of the image. Incorrect thickness of the coverglass can blur the image when using dry objectives with a high NA. The image sharpness can be restored by using the correction collar on the lens. If this is unavailable, another objective will have to be selected, and this usually means substituting an oil immersion for a dry objective.

When recording transparent specimens, the microscopist may need to resort to special techniques for enhancing contrast. One of the easiest to implement is darkfield illumination, which creates dramatic images. Another technique for transparent samples is phase contrast and DIC. Both of these techniques are used extensively for studying live cells. Phase contrast accessories are available readily on used microscopes. Microscopes such as the Leitz Ortholux or the Zeiss GFL, which were made in the 1960s, can be easily outfitted with phase contrast. The cost of these accessories is moderate and most hobbyists can acquire them. In contrast, DIC is more difficult and more expensive to fit to a microscope.

CHAPTER SEVEN
MOVIES

The modern digital SLR and mirrorless cameras are hybrid recorders capable of taking still photographs and movies, and the resolution of their movies is better than that of the dedicated photomicrography cameras. Perhaps the most intuitive way to approach movie taking is to start by discussing the number of pixels in a picture frame. For someone who is familiar with still photographs, this provides a familiar means of comparing different cameras.

Pixel Array and Movies

As you know, movies are based on recording a sequential series of still images. Each frame can be as small as 0.3 megapixels (640 x 480 pixels) or as large as 4096 x 2160 pixels (eight megapixels). Dedicated photomicrography cameras tend to record smaller frame videos, while mirrorless or digital SLR cameras record the largest.

Differing frame size reflects how much data must be transmitted or processed. In the case of dedicated photomicrography cameras the size of the movie files is small due to their small frame size of about 0.3 megapixels. This allows them to be sent via a USB cable directly to the computer. For mirrorless or digital SLR cameras, the data is recorded in one of two ways. It is either sent to an internal memory card, or is transmitted to an external recorder via an HDMI ('high definition multi-media interface'). These files are quite large, and their frame size is 2.1 megapixels for HD

Table 10: Digital file formats and the number of pixels contained in them when taking movies

File size	Pixel array	Camera types
4K, DCI (digital cinema initiative)	4096 x 2160	Digital SLR and mirrorless cameras
4K, UHDT (ultra high definition television)	3840 x 2160	Digital SLR and mirrorless cameras
1080i, 1080p, HD (high definition)	1980 x 1080	Digital SLR and mirrorless cameras, some dedicated photomicrography cameras
720p	720 x 1280	Digital SLR and mirrorless cameras
480p, VGA (video graphics array)	480 x 640	Dedicated photomicrography cameras

and eight megapixels for 4K. The size of these files precludes their transmission via a USB cable to a computer. Moreover there is so much data that advanced compression algorithms must be used to save these files.

Table 10 shows the pixel array of different video formats. The big increase in resolution occurs when using HD (high definition) cameras. The pixel array numbers refer to the number of pixels along the horizontal and vertical axis of the frame, while the p and i that appear with some of the file size values refer to the method of scanning: p is progressive and i is interlaced. These terms will be described in the next section on scanning. The 720p array is 720 pixels on the vertical axis, with 1280 pixels along the horizontal axis. This is a significant increase in pixel count over VGA (video graphics array) generated by older cameras. 720p is used frequently for taking pictures at high frame rates (100fps). For example, a 1080p camera may only record pixels at 50fps, but if set to 720p it may be able to record to 100fps.

For those wishing to record at even higher pixel counts, there are 4K videos. The file size nomenclature can be confusing when describing 4K videos because '4K' refers to the approximate number of pixels along the horizontal rather than the vertical axis. In addition, 4K is divided into two groups: DCI (digital cinema initiative) or UHDT (ultra high definition television). As its name indicates, DCI is used for cinematic productions for movies, while UHDT is used for television broadcast. In terms of pixel count, we are going from a high of about eight megapixels per frame (4K) to a low of about 0.3 megapixels per frame (VGA).

Digital File Formats

The number of pixels per frame relates to how much data is transmitted to the memory card. This is the bit rate, and is measured in Mbps (megabits per second). A higher Mbps indicates that more data is being recorded. For example, a Panasonic GH4 camera records a VGA file at four Mbps, and a 4K video file at 100 Mbps. Different degrees of compression also affect the Mbps rate; thus the greater the compression, the lower the Mbps rate, and the more the data becomes degraded. For the maximum detail from recording an HD or 4K video, one needs to use the highest Mbps value possible. Table 11 shows the bit rate and the recommended cards to be used in a Panasonic GH4 camera.

As a general rule, to take and edit the highest pixel count movies, the microscopist must be prepared to invest in cutting-edge technology. These types of camera are expensive. The Panasonic GH4 is a rela-

Table 11: The recommended card's speed class in comparison to its Mbps		
Recording format	Bit rate	Speed class of card
AVCHD	28 Mbps	Class 4 card or higher
MP4	100 Mbps	UHS (ultra high speed) Class 3
MP4	28 Mbps or lower	Class 4 or higher
MOV	100 Mbps or higher	UHS (ultra high speed) Class 3
MOV	50 Mbps	Class 10

tively low-priced 4K camera but it still costs £850 new, without lens. And in addition to the camera, one has to invest in faster accessories, such as memory cards and computers.

To save 4K movies to internal memory requires fast memory cards. These are classified by the speed with which they accept data (Table 11). The least expensive cards are the slowest. In terms of speed rating, the cards start off as Class 2 and go up to Class 10. Panasonic GH4 claims that a Class 4 card can be used for their AVCHD files; however, we prefer using the Class 10 card: it is not much more expensive than a Class 2, and it can transmit at almost twice the data rate (fifty Mbps). Cards become significantly more expensive when storing 4K videos. In this case you need to buy UHS (ultra high speed), which are graded from a Class 1 through to Class 3. To give you an idea of their expense, at the time of writing a non-UHS Kingston Class 10 memory card costs about £18.99, a UHS-1 card costs £24.65, and an Extreme Pro UHS-3 costs £52.30.

Saving HD Movie Files

The most convenient way to save HD and 4K movie files is to save them to the camera's internal memory card. Once saved, you will need to remove the card from the camera. Files are then transferred to a computer using a card reader. External card readers are accessories that can be plugged into a USB port. Many laptop computers have a built-in card reader.

The second way to save the files is to send them via the camera's HDMI port to an external recorder that is connected to a hard disk or an external SSD ('solid state drive'). An example of one is the Atomos Shogun. This device costs about £1,400, not including the mass storage medium.

Before buying a camera, you should study its specifications carefully. In at least one model, the Sony a7S, you have to save the 4K output via the HDMI port: it cannot be saved to an internal memory card. The replacement for this camera, the Sony a7s II, allows direct recording to its SD card. Dedicated photomicrography cameras may save their files via the USB ports. Generally, these cameras do not record movies that have HD resolution.

The software for reading movie files is complicated, and you may have to buy editing software. The first software to use is the one that comes with the camera. Generally, the manufacturers provide a proprietary software package for opening their video files. If you need to purchase software, for 4K and HD videos there is Adobe's Premiere Pro CC and Apple's Final Cut Pro X. These software packages are expensive. Adobe's software is licensed by subscription at £17.50 per month, while Apple's software is purchased at £229.99. Fortunately these programs have a free trial period and they can be evaluated before purchase. To master these complex programs requires an investment in time and effort. Mac aficionados have a low cost alternative if they buy iMovies.

If you wish to edit 4K videos, you have to decide how much computer power you will need. To edit these files directly (online editing) will require a powerful desktop machine that may cost up to £12,000. Its speed is needed so you can rapidly scan through the recording and select those portions of the clip that you will use, and reject those you will not. Afterwards you can join the selected clips and possibly include transition material, such as still photographs or text slides. However, it is possible to edit these movies on a much less expensive computer. We have done so with a MacBook Pro laptop computer by using offline editing. This means you create a lower resolution proxy file of the original 4K recording. The proxy file is small enough to be edited on a laptop computer. After editing, the proxy is converted back to a 4K movie, which requires replacing all the proxy footage with the original 4K material.

The photomicrographer naturally wants to record the highest pixel resolution; however, this can become an expensive proposition. The highly competent Panasonic GH4 records 4K and costs £850. In contrast, the 4K cameras by Nikon and Canon cost twice as much.

Interlaced Scanning

Table 10 includes numbers with lower case letters, i and p. These letters describe how the images are scanned, where i refers to interlaced scanning and p refers to progressive scanning.

Due to technological limitations, older analog cameras and broadcast televisions form images using interlaced scanning. To display images sequentially and convey smooth movement, two fields are collected and combined to make a single frame. For example, if the digital camera has a sensor with a spatial resolution of 600 horizontal lines, it collects only half of them, starting with the top line and then collecting every other line to create a 300 horizontal line image. This collection is one field. Then the sensor collects the remaining 300 lines for the second field. The two fields are combined at playback to yield a single frame of 600 lines. In essence, to display a movie at 30fps, a camera or television has to collect sixty fields per second: that is, two sets of thirty fields per second that are interlaced to form thirty frames per second (Fig. 72).

If the object moves while the two fields are being recorded, the edges of its image will not line up when the two fields are combined into a single frame. This causes a blurring in the resulting frame, which can be beneficial in the perception of fluid movement by creating a smoothing effect when the frames are viewed.

Progressive Scanning

The letter p in a description of the video file indicates that progressive scanning has been used to capture the frame. This is the modern way to record and play back movies. All computer monitors use progressive scanning to display images.

Collecting images by progressive scanning is easy to understand. Basically, the sensor sends the horizontal lines of a frame in sequence and displays them all at once (Fig. 73). Because of this, the moving borders are kept in alignment. If you look at a single frame, you will see that it provides the highest definition for regions that move from frame to frame.

This is not to say that there are no artefacts. Progressive scanning has some peculiarities. Because of the sharpness of the individual images in a frame, movement during playback may not be perceived as moving fluidly. The very sharpness of the moving edges creates an impression of movement that seems to stutter. To create a fluid motion, most videographers will actually blur the subject by using a slow shutter speed of $1/100$ second when shooting at 50fps. This blurs the edges of a moving subject and creates the perception of fluid movement during playback. If a shutter speed of $1/1000$ second is used, the motion appears strobe-like and most likely will be aesthetically undesirable. This is most apparent when you record at 24fps with a fast shutter speed.

Another artefact of progressive scanning is the rolling shutter. This is a defect where the shape of the subject is altered as it moves. Because the camera captures the image progressively from top to bottom, the image may have moved between recording the first and collecting the last line – in other words, there is temporal offset in recording from top to bottom. If a vertically orientated bar moves across the field of the sensor, it will be recorded as diagonal. To reduce this

Fig. 72 A schematic showing the effects of two fields being captured by interlaced scanning and the misalignment of a moving object's borders when the fields are combined in a frame.

Fig. 73 A diagram showing three frames being captured by progressive scanning where the edges of a moving border stay aligned.

defect, one should record at a higher frame rate.

PAL or NTSC

Cameras can make recordings for one of two broadcast standards: PAL or NTSC. The PAL standard is used in the UK and Europe with the following fps options: 25, 50 and 100fps. In contrast, the NTSC standard is used in the United States with the following fps options: 30, 60 and 120fps. Some camera manufacturers do not allow you to alter the camera's frequency: it is preset by them, and is determined by where you purchase the camera. A few cameras allow you to set the system frequency as a menu command. In the case of the Panasonic GH4, you will select the frequency and broadcast standard via a menu selection. This is not a trivial process, because once the selection is made, the camera has to be turned off, and then back on again before it can be used.

Video and Playback Rate

A video can be thought of as a series of still photographs taken in sequence and played back at a rate so as to show motion. The playback speed governs how the movement is perceived. Typically, the recording and playback settings are the same, and It might be thought that the best one to use would be the fastest. This is understandable. Aside from reducing the effects of the rolling shutter, there is a hidden benefit in using a fast frame rate because you can take the clip and slow it down in playback. For example, record a video at 100fps and then play it back at 25fps, and perceived motion is slowed by one quarter. This is advantageous when filming rapid dynamic events, when the movement is too fast for the eye to follow the action.

For digital SLRs and mirrorless cameras, this feature is best accomplished by taking HD, rather than 4K, videos. When taking 4K, the fastest frame rate is usually limited to 30fps. In contrast, most cameras allow taking HD videos at 50fps, and a few of the most recent camera models can record HD at 100fps. This is a high rate of data transfer. To lower this rate, manufacturers will reduce the pixel array from 1920 x 1080 to 1280 x 720 pixels.

Shutter Speed and Frame Rates

In comparison to still photography, the range of usable shutter speeds is constrained when taking a video. For example, when recording a movie at twenty-five frames per second, most video cameras will not allow you to set a shutter speed duration longer than $1/25$ sec. Among the exceptions are the Sony mirrorless cameras. These cameras allow you to set shutter speeds as long as $1/6$ sec when taking movies at 25fps. This unusual feature requires the camera to use image-processing software to combine four frames, making the resultant frame equivalent to an exposure of $1/6$ sec. It requires you to set the shutter

speed manually. If you rely on the camera to set its exposure automatically, it will keep the shutter speed duration to $1/30$ sec.

To accomplish this feat, Sony uses a temporal averaging algorithm that combines four frames. The effect reduces the appearance of noise in the picture, and is an example of noise reduction by frame averaging. It is as if four images were collected in a buffer to generate an average. When a camera records a new frame, it is inserted into the buffer. The frames are averaged, and the resultant frame from the buffer is sent out to both the display and the memory card. For rapidly moving objects, it will blur the moving subject and create a ghostly tail. For the artistic minded, this can create an ethereal effect.

Dedicated photomicrography cameras may have this temporal averaging feature as a user-selectable command. As might be expected, you have a greater degree of control in that you can select how many frames you wish to average. For those who work with dimly lit specimens this is a handy feature.

Motion can be rendered smoothly, or it may appear to move in tiny jumps, as if the subject is stuttering. A fast shutter speed exaggerates this spasmodic appearance. For example, if you shoot at 25fps, the desired shutter speed to use is $1/50$ sec. If you set the shutter speed to $1/500$ sec the subject's motion will appear jerky in comparison to shooting the scene at $1/50$ sec. Most mirrorless and digital SLR cameras are designed as still photography instruments so their shutter speed settings are set as fractions of a second. In contrast, videographers are conscious of the importance of maintaining a constant ratio between shutter speed and frame rate.

Professional cinema gear uses degrees to set their shutter speed. This reflects the importance of controlling the ratio that a frame is exposed to light, to when it is in the dark. Traditionally, this is a 1:1 ratio and motion appears 'natural'. For example, when an object moves slowly across the screen, the viewer can

Table 12: The shutter speed to be used at different frame rates to maintain a 180 degree setting

Frame rates	Recommended shutter speed
25	[1/50]sec
50	[1/100]sec
100	[1/200]sec

see its details; however, for objects moving rapidly, they appear blurred. To appreciate this, imagine a bicyclist pedalling rapidly across the scene. When shot with a 1:1 ratio of light to dark, the bicyclist's face can be followed; however, the spokes of the bicycle's wheels will be blurred so the individual spokes are not visible. The appearance of movement in this movie appears natural. If one uses a very fast shutter speed, the viewer will see the individual spokes of the wheels as the tire rotates. Perceptually this is disconcerting as it does not match up to our real-life experience.

Movie makers are conscious of this, so in a brightly lit scene, instead of using a fast shutter speed to reduce exposure, they use neutral density filters to maintain the lighting ratio of 1:1. Historically, movie cameras used a rotating shutter, and to get this ratio, the shutter speed was expressed in degrees equating 1:1 lighting ratio to 180 degrees. Fewer degrees and the shutter speed would be faster than desired, while with a greater degree it would be slower. In either case, the motion in the movie would appear unnatural.

In the case of the 25fps movie, you should use a shutter speed of $1/50$ sec to provide a realistic rendering of motion. For a movie taken at 100fps you should use a shutter speed of $1/200$ sec (see Table 7).

Three Camera Types We Use for HD and 4K Videos

It is impossible to gain practical experience of all the cameras available for photomicrography. The sheer number of different models and the rapidity with which they are replaced ensures it is a task that cannot be completed by one person. However, it is possible to gain experience by using a few different cameras.

Our experience ranges from using the full frame Sony mirrorless cameras to the smaller sensor dedicated photomicrography cameras. The former have a full frame sensor of 24 x 36mm, while the latter have a small sensor of 5.76 x 4.29mm. The different size sensors require different magnifications for their relay lenses. The small sensor is often found in cameras designed to work on C-mount photographic ports. Many of these cameras are dedicated photomicrography units, and the manufacturer will recommend a relay lens of 0.3 to 0.5 power. In terms of dedicated cameras, we have worked with a Lumenera Infinity 2-2 camera and a Tucsen TrueChrome II camera. Both of these cameras are designed to be used with a 0.5x relay lens. In contrast, the larger full frame sensors require a higher magnification relay lens. For our Olympus BX51 we use a 2.5x relays lens for a full frame camera such as a Sony a7, or a 1.5x relays lens for APS-C size sensors used in the NEX-6.

The Lumenera is a typical dedicated camera used in research laboratories and universities. It typifies the dedicated photomicrography camera in that it requires a computer. It is connected with a USB 2.0 port, and can generate a frame having 1616 x 1216 pixels. Basically it is a 2.0 megapixel camera, and it transmits at 15fps to the computer. As a scientific camera it has flat field correction, binning, and user-defined ROI. The one caveat is that as a computer's operating system is upgraded, the camera's drivers may also have to be changed.

In contrast, the Tucsen TrueChrome II camera is a self-contained unit with all its software and controls contained within the camera body. It can be equipped with an LCD monitor that is mounted on the camera body. An included mouse is used to select commands displayed on the monitor. Image files are then saved to a removable SD card. The camera does not require a computer. The advantage of this design is the speed with which the screen can be refreshed: its refresh rate is twice that of the Infinity 2-2. It outputs an HD signal via an HDMI port which drives the monitor.

The absence of a computer makes this unit convenient to use when testing different microscopes. As long as the trinocular port has a C-mount, the camera can be mounted and used immediately for taking pictures and videos.

We also use mirrorless cameras such as the Panasonic GH4 and the Sony a7R II. Both cameras have a larger sensor: the GH4 is 17.3 x 13mm, while the Sony is 24 x 36mm. Both of these cameras take 4K video at a frame rate of 30fps, and you can take time-lapse sequences. In the case of the Panasonic, the software is built into the camera body.

For the Sony, it is an add-on app which is purchased and downloaded from Sony's web site. In this case, the shortest interval that it can take for a time lapse is one second between frames – so when the movie is played, the subject's apparent motion is 25x faster than real life. This can be a problem if you wish to show motion that is speeded up less than 25x. For example, if you want to accelerate the speed with which an amoeba encircles its prey, you may only want to speed up the scene by 5x.

In such cases, you will need to have an ability to record at frame rates between 1 and 25fps. For example, if you change the frame rate for capturing a scene to 5fps, when it is played back at 25fps the recorded motion will appear to be moving 5x faster. If the camera does not provide an option to reduce the frame rate from 25fps to 5fps, all is not lost. With software, such as is the case with Final Cut Pro, you can record a scene at 25fps, but post process it so that the motion appears 2x, 4x, 8x or 20x faster. This is accomplished by not playing back every frame, but instead, to increase the subject's movement by 2x, only every other frame. By selecting the number of frames to skip, you can view a movie that will speed up movement. In contrast, the Panasonic camera is more efficient for this work in that you can adjust its frame rate for acquiring pictures as a camera setting. You can set

it to take frames at 2, 12 or 23fps.

Both of the above cameras have extensive settings for adjusting the contrast, brightness and colour of the recorded movie – although these features are of more interest for the general photographer than they are for the photomicrographer. When photographing outdoor scenes with a large range between highlights and shadows, these settings allow greater flexibility during post processing. But this is not the case for the photomicrographer whose subjects are of low contrast.

One of the disadvantages of using the larger sensor cameras is the requirement for an enlarged imaging circle to encompass the area of the sensor. Since light intensity falls off as a square of the magnification, a more intense light is needed when shooting with a full frame camera than with one of the small sensor cameras that are found on the Lumenera and Tucsen. The problem arises when shooting live specimens, because many organisms are sensitive to the heat generated by tungsten or quartz halogen bulbs. Since the full frame camera uses a 2.5x relay lens while the Tucsen or Lumenera camera use a 0.5x lens, the former requires 5x more magnification, translating into a 25x greater increase in light. This will result in greater heat being focused on the specimen.

In summary, for still photographs of the highest quality we will use the Sony a7 series full frame cameras. However, when we take videos of living organisms, we prefer to use the Panasonic GH4 or one of the dedicated photomicrography cameras, because their smaller sensors allow us to use less light.

Putting it Together When Taking Videos

The tools for taking the sharpest videos are digital SLRs and mirrorless cameras. Especially with the advent of 4K, these cameras take far sharper movies than those recorded by dedicated photomicrography cameras. A frame from a 4K video consists of eight megapixels, and this contains enough detail for making a high quality 8 x 10in print. The disadvantage of this format is expense. To fully exploit its capabilities one needs a computer for video processing. Moreover, a 4K monitor or projector is expensive.

A more economical solution is to use HD video. Here the cameras are more affordable, and you can get by with less expensive computers for digital editing. The reduced number of pixels is not a major handicap if you take care and make sure the specimen occupies most of the area within the frame. If you do so, the projected image will appear sharp and with good definition.

A full frame sensor is unnecessary for taking videos, and indeed it is a disadvantage when working with light inefficient techniques such as DIC, polarization microscopy, fluorescence and darkfield illumination. Because of its larger overall size, more magnification is needed to illuminate its sensor fully. In contrast, less magnification is needed when using a smaller size sensor. For our work with 4K video, we prefer the Four Thirds sensor of the Panasonic GH4 combined with a 1.5x adapter (the full frame requires a 2.5x) so we can use a shorter shutter speed when taking a movie. If the subject is very dim, such as when recording fluorescent samples, we will use a camera with an even smaller format sensor, such as the one in the Tucsen TrueChrome that provides HD recording capability.

Our desire for using shorter speeds on our video is for our projects on expanding the depth of field of our microscopes. Normally for still photography we do this by incrementally changing the fine focus and taking a picture at that focus setting. Now we have adopted using video for thick specimens. The software, Helicon Focus, will import a video clip and translate the frames into JPG files. If the focus is changed while taking the video, these are then used by the program for creating an image with an extended depth of field. Since twenty-five frames can be captured in 1sec, this can make short work out of harvesting enough optical sections from a thick specimen. In this situation, we use a very short shutter speed when acquiring the image, setting it to $1/1000$ sec. The quality of a single frame from a 4K video is sufficient to produce sharp still images (Fig. 74).

Fig. 74 An extended depth-of-field image of a diatom arrangement made from a 4K video sequence.

Microscope Set-up for Video Work

The microscope we use for taking videos is similar to what we use for still photography. However, we feel that some features on the microscope help facilitate taking movies.

The first is a high intensity illuminator. This is used for light-intensive imaging modalities such as darkfield, DIC, polarization or phase contrast illumination. Our microscope is equipped with either a quartz halogen bulb (12V 100W) or a high intensity white light LED illuminator (30W). The latter is about twice the brightness as our quartz halogen illuminator and provides a much cooler light. With both light sources, we insert a heat-absorption filter in the light path.

Both of the above illuminators generate too intense a light for brightfield and need to be dimmed. This is done with a set of Bausch and Lomb neutral density filters. These are coated with Inconel, which does not impart any colour hue to the light.

We do not lower light intensity by reducing the voltage to the quartz halogen bulb, since this shifts its colour temperature towards ruddy hues. Nor do we make use of pulse width modification (PWM) to diminish LED light output. This type of light attenuation is performed by rapidly cycling the light on and off. The rapidity of this cycling is so fast that the light appears to be on continuously. However, by increasing the cycle time when the illuminator is off, its light output is reduced. When PWM is done at a high frequency, you should not see flickering when looking through the oculars. However, depending on the shutter speed of the recording camera, you can see, during the movie playback, either an uneven field of view or a flickering. Consequently we always run the LED at full intensity and decrease its light by applying neutral density filters.

We do not recommend using variable neutral density filters. These are two polarizing filters mounted together so that by rotating one while keeping the other fixed, the transmission of light is reduced. We have tried this and found that there is a change in the white balance of the light. As one attenuates the light, it tends to become cooler.

Conclusion

Digital SLR and mirrorless cameras are the best tools for taking movies with a high pixel count. Especially with the advent of HD and 4K, these cameras provide higher resolution images than the dedicated scientific camera. When working with video, we prefer the Four Thirds sensor cameras, and if we are working with very faint specimens, we will use a small sensor camera. One of the nice features of these cameras is that the video mode uses an all-electronic shutter, so taking the video will not impart any movement to the camera.

With 4K and HD video, the cameras can provide sharp still photographs. We take advantage of this feature to help us quickly take an extended depth of field, so it is possible to take an extended depth of field of a living organism.

FURTHER INFORMATION

Online Resources

http://micro.magnet.fsu.edu/primer/
Florida State University site on microscopes. An excellent teaching aid with coloured illustrations. Java tutorials for learning the principles of optics.

http://www.science-info.net/docs/
Gordon Cougar's website that has archives on the older microscope manuals.

http://www.savazzi.net/
Enrico Savazzi's website which contains articles on macrophotography and photomicrography.

http://www.the-ultraphot-shop.org.uk/
Spike Walker's website on the Zeiss Ultraphot microscope. There are interesting articles for generating colour phase contrast. Although it deals with the Ultraphot microscope, his techniques can be adapted to other microscope stands.

https://groups.yahoo.com/neo/groups/Microscope/info
An online forum consisting of professional and amateur microscopists. The discussions and archives deal mostly with optical hardware and techniques.

https://groups.yahoo.com/neo/groups/Amateur_Microscopy/info
An online forum consisting of professional and amateur microscopists. The discussions tend to be directed for outreach programs for teaching microscopy as well as descriptions of what people are viewing with their microscopes.

https://www.microscopy.org/
This is the website for Microscopy Society of America. It is primarily an organization for professionals and publishes the journal, Microscopy and Microanalysis.

http://www.rms.org.uk
This is the website for the Royal Microscopical Society. It is primarily an organization for professionals and publishes the Journal of Microscopy.

http://www.alanwood.net/
Alan Wood's website which is an excellent reference source for the Olympus OM camera system and the finite tube length Olympus microscopes.

http://www.krebsmicro.com/
Charles Krebs' website for photomicrography. Extremely useful information on adapting cameras to microscopes written by recognized expert in photomicrography,

http://www.photomacrography.net/forum/
An online forum for people interested in macrophotography and photomicrography.

http://www.microscopy-uk.org.uk
An online magazine presenting a plethora of articles on microscopes and microscopy. The articles are written mostly by avocational microscopists.

http://www.micrographia.com
This website was created by the late John C. Walsh and is maintained by his friends. There are articles on photomicrography and on specimens which can be observed by the naturalist.

http://www.victorianmicroscopeslides.com/slides.htm

This website is made and maintained by Howard Lynk and provides a detailed description of collectible microscope slides.

Below are two websites, maintained by the McCrone Group, that contain free articles of value to microscopists.

https://www.mccrone.com/mm/an-introduction-to-the-microscopical-study-of-diatoms-2/

An Introduction to the Microscopical Study of Diatoms, January 7, 2013 by Robert Mclaughlin

https://www.mccrone.com/mm/narcotizing-slowing-down-and-preserving-microscopic-and-other-aquatic-animals/

Narcotizing, Slowing Down, and Preserving Microscopic and other Aquatic Animals, June 16, 2008 by John Gustav Delly

http://www.heliconsoft.com/heliconsoft-products/helicon-focus/

The website for the software company Helicon Soft that sells an extended depth of field software. It has three grades of software, and it is possible to purchase a lifetime licensc. There is a 30 day free trial for testing the software.

http://zerenesystems.com/

The site for downloading an extended depth of field sotfware. There are four levels of software license. The most expensive edition is for those interested in selling their photographs. One can easily upgrade the license from Personal Edition to Professional. There is a 30 day free trial period for testing the software.

https://imagej.net/Fiji

This is a scientific grade image processing program that is available for free. It is available for MacOS, Windows, or Unix computers.

Books

This is a list of books I found to be useful. Although some are dated, they provide a view on the traditional approaches to microscopy. For example, the photomicrography books deal with film rather than electronic cameras. The book written by Inoué and Spring as well as the one written by Murphy and Davidson provide a review of modern approaches to microscopy and electronic image acquisition.

Carpenter, W.B. revised Dallinger, W.B. (1891) *The Microscope and its Revelations, vols. I and II,* London: J. and A. Churchill (1883).

Delly, J.G. (1988) *Photography Through the Microscope,* Eastman Kodak Company, Rochester, New York

Garnett, W.J. (1962) *Freshwater Microscopy,* London: Constable and Co. Ltd.

Inoué, S. and Spring, K. R. (1997) *Video Microscopy: The Fundamentals,* Plenum Press: New York and London.

Loveland, R. P. (1970); *Photomicrography: A Comprehensive Treatise,* 2 vols. John Wiley and Sons: New York.

Murphy, D. B. and Davidson, M. W. (2012) *Fundamentals of Light Microscopy and Electronic Imaging.* Wiley-Blackwell: Hoboken.

Needham, G.H. (1958) *Practical Use of the Microscope: Including Photomicrography,* C. C. Thomas Publishers: Springfield.

Nomenclature Committee of the RMS and Bradbury, S.(1989) *RMS Dictionary of Light Microscopy* (Royal Microscopical Society Microscopy Handbooks), Oxford University Press: Oxford.

Rost, F. W. D. (1995) *Fluorescence Microscopy,* vols. I and II, Cambridge University Press: Cambridge.

Shillaber, C.P. (1944) *Photomicrography In Theory and Practice,* John Wiley & Sons:, New York.

INDEX

4K video 71, 95–97
Abbe condenser 28, 43
achromatic 18–19
 condenser 28
 objective 19
afocal photography 45–47
angular aperture 20
apochromatic 19, 39
AVCHD 96
AWB 71
binning and gain 59–60
binocular stereo microscope 34–35
binocular head 9
bit levels 64–66
C-mount 30, 55–57
 attaching mirrorless Digital SLR 55–56
 dedicated cameras 56
 Tucsen 101
cameras 45–61
 afocal 45–47
 cell-phone camera 46–47
 Coolpix 46
 dedicated cameras 57–60
 EFCS (electronic first curtain shutter) 48
 full frame sensors 60
 Lumenera 101–102
 mirrorless 47–56
 sensor array and magnification 60–61
 Sony 47, 48, 50, 56, 65, 79, 97, 99, 101
 Panasonic 48, 56, 71, 95–98, 101
 Tucsen **57**, 101–102
 videos 101–103

chromatic aberration **18**, 19, 28, 30, **39**, 43
cleaning 78–80
 lens 78–79
 sensor 79–80
coarse focus **9**, 10, 11, 27, 55
colour 68–69
 Bayer mask 66, **69**
 RGB histogram 76
 primary 69
 recording 68
 temperature 29, 50
 white balance 71–72
compensating eyepiece 30
compound microscope 7, 9–19
condenser 12–15, 44
 Abbe 28, 43
 achromatic 28
 centring screws 12, 29
 darkfield 84–85
 dry 26, 43
 immersion 26, 79
 iris diaphragm 12, 14, 25
 low power 34
 Nikon 28
 phase contrast 89
 role in contrast **25, 26**, 82
 role in resolution 25
 upgrading 28, 42
contrast enhancement 82–93
 darkfield illumination 83–85
 differential interference contrast 92–93
 filter 81

INDEX

fluorescence microscopy 85–88
iris diaphragm 82
phase contrast illumination 88–92
phase contrast vs. differential interference contrast 93
correction collar 33, 80–81
coupling camera to microscope 51–58
 non-contact coupling 51–52
 direct coupling 52–55
 dedicated cameras 55–56
coverglass 8, 9, 32, 33
 correcting 80–81
 effects on contrast 80
 thickness 9, 33
DIC *see* contrast enhancement
dedicated camera 56–61
 binning 59–60
 communication 58
 refresh rate 58
 FireWire 58
 gain 59–60
 HDMI 101
 USB 58, 100
DCI (digital cinema initiative) **95**, 96
digital-SLR 47–51, 55, 69
DNG (digital negative) *see* file format
EFCS (electronic first curtain shutter) 48
electronic flash 49
exposure 72–76
eyepiece 8, **9**, 10, 11
 photographic 46–47, 53–54
 visual 30–31
fibre-optic illuminator 35
field diaphragm **10**,12, 24–25, 28–29
field number 10, 30
file format 69–70
 AVCHD 96
 DNG 70
 JPEG 68–70
 MOV 96
 MP4 96
 RAW 70, 77, 86
 TIFF 70, 73
film camera adapters 52–55
 Leitz Mikas 54
 Nikon F adapter **54**
 Nikon PFM **52**, 54
fine focus 9, 11, 27
FireWire 58
first-order **22**
flash 49–51
fluorescence 85-88
 binning and gain 74
 gain 86
 white balance 72
focusing aids 70-71
 enlarging 68
 HD monitor 69
 low light 60
 peaking 70
FN *see* field number
gain 72–74
Hastings triplet magnifier 18
HD television 70
HDMI 50, 70, 97, 101
highlight, warning 76
histogram exposure guide 75–76
Inconel filter 29, 103
infinity optics 31, 42
illumination, Nelson and Köhler 24–26, 43
illuminator 10, 11, 15, 24, 35, 71, 86, 103
 halogen bulb 15, 71, 102
 mercury arc 86
 tungsten bulb 15, 24, 102
infinity optical tube length 42
interlaced scanning 96, 98
interpupillary adjustment 10
ISO 72–74

Kelvin 72
Köhler illumination 10, 12–15, 25, 34
Leitz MIKAS adapter 52–55
lens, cleaning 78–79
lossless compression 70
lossy compression 69
loupe 16–18
Lumenera *see* cameras
magnification changer 30, 61, 67
magnifiers 8, 16–18
mechanical stage 9, 11, 15, 27
microscope head 11, 30, 73
microscope parts 9–12
mirror lock-up 50, 51
mirrorless-cameras *see* cameras
monocular dissecting microscope 33–34
MOV 96
MP4 96
MRD 21, 36, 37
NA *see* numerical aperture
Nelson critical illumination 24–25, 43
neutral density filters 29, 49, 72, 100, 103, 104
Nikon Coolpix 950 46
Nikon PFM adapter 52–55
Nikon F adapter **53**
NKF eyepiece 51, 54, 55
noise 58–59
 gain vs binning 73
 reducing with Photoshop 73, **74**
non-contact coupling camera to microscope 51–52
nosepiece 11
NTSC 99
NA (numerical aperture) 20–23, 25
 controlling contrast 26
 fluorescence 87
 low-light work 73
Nyquist criterion 66–67
objective 8, 9, 10–11, 19–24
 1x, 2x 34

achromatic 19
apochromatic 19
choosing 36–42
correction collar 33, 37
dry 14, **23**, 33
oil immersion 14, **22**, **36**, 40
semi-apochromat 17, 39
types 41–42
upgrading 36–39
water immersion 33, 36, 41
working distance 36
Olympus NKF eyepiece 51, 54, 55
optical section 24, 102
Optovar 30, 61
PAL 99
Panasonic cameras *see* cameras
peaking 70
Periplan eyepiece 46
phase contrast 88–92
 comparison to DIC 93
 negative 91
 phase centering telescope 42
 positive 91
phase telescope 42
photographing samples 81–93
 fluorescent 85–88
 stained 81–82
 unstained 83–85, 88–93
pixels 62–69
 Nyquist criteria 66
 size and resolution 66–68
progressive scanning 96, 98
RAW *see* file formats
real image 8, 19
refractive index 20, 40, 41
region of interest *see* ROI
residual chromatic aberration 19, 39
resolution *see* MRD
ribbon filament bulb 24

ROI (region of interest) 59
samples, unstained 83–85, 88–93
SD memory cards 97
sensor array and magnification 60
sensor cleaning 79–80
simple microscope 8, 17–18
simple and compound microscope 7–8
slide 8–9, 32
Sony cameras *see* cameras
source-focused illumination *see* Nelson critical illumination
spherical aberration 20, 28, 33, 39–40
stage 9–11, **27**–28
stereo microscope 34–35
substage 28–**30**
TIFF (tagged image file format) *see* file format
trinocular head **9**–11
Tucsen *see* camera

UHDT (ultrahigh definition television) **95**, 96
upright microscope 9
USB communication 58
variable neutral density filters 103
VGA (video graphics array) 95
vibration 47–61
 causes 56
 prevention 48–51, 53, 54, 56
 vibration 47–51
video formats 96
virtual image 8, 19
white balance 71–72
 fluorescence 86
 neutral density filter 29, 103
 setting 72
WiFi 71
zero-order **22**

RELATED TITLES FROM CROWOOD

Close-up and Macro Photography: Art and Techniques
John Humphrey
ISBN: 978 1 84797 597 3

Extreme Close-Up Photography and Focus Stacking
Julian Cremona
ISBN: 978 1 84797 719 9

Insect Microscopy
Andrew Chick
ISBN: 978 1 78500 201 4

Understanding Your Digital Camera: Art and Techniques
Tim Savage
ISBN: 978 1 84797 802 8